Key West
and the Florida Keys

ON THE FRONT COVER: On January 25, 1928, the Over-Sea Highway opened. Utilizing connecting bridges between keys, the new roadway offered almost uninterrupted travel for automobiles. Only two stretches between Lower Matecumbe and No Name Key required a ferryboat ride. At the southern end of the highway, the Boca Chica Bridge led visitors into Key West. (Authors' collection.)

ON THE BACK COVER: From the destruction wrought by the 1935 hurricane came something quite beneficial to all of the Florida Keys. After the Key West Extension of the railroad closed, federal and state funds were used to purchase the company's bridges, roadbed, and right-of-way. In 1938, with great fanfare, the new Overseas Highway opened. Uninterrupted automobile travel from the mainland to Key West was now a reality. (Authors' collection.)

POSTCARD HISTORY SERIES

Key West
and the *Florida Keys*

Lynn M. Homan and Thomas Reilly

ARCADIA
PUBLISHING

Published by Arcadia Publishing
Charleston SC, Chicago IL, Portsmouth NH, San Francisco CA

Printed in the United States of America

Library of Congress Catalog Card Number: 2006924604

For all general information contact Arcadia Publishing at:
Telephone 843-853-2070
Fax 843-853-0044
E-mail sales@arcadiapublishing.com
For customer service and orders:
Toll-Free 1-888-313-2665

Visit us on the Internet at www.arcadiapublishing.com

CONTENTS

ACKNOWLEDGMENTS

Postcards often present different views of a particular area than those shown by photographs. Photographs frequently feature the people and places important to the individual taking the picture. Postcards, for the most part, have been prepared commercially to illustrate scenes and subjects deemed most important to the community and its visitors. In addition to our own collection of postcards, we were able to use a number of very special images from the State Library and Archives of Florida, the Key West Art and Historical Society, and the Special Collections of the Monroe County Public Library. Thanks to the dedicated archivists at these facilities, everyone, rather than just the original recipients, can enjoy these postcards.

Postcards are not just a thing of the past. Talented photographers are still recording images that cry out to be made into postcards. These include several views of local scenes captured by Dale M. McDonald and made available through the Florida Memory Project of the State Library and Archives of Florida. And perhaps someday, years from now, the digital photographs of today's visitors to the Florida Keys will be the historical postcards valued by future collectors.

INTRODUCTION

Today we live in a world made smaller by modern communication technologies. Cell phones, e-mail, and instant messaging are all part of our daily lives, but that wasn't always the case. In an earlier era, postcards were a popular means of communication for millions of people. Postcards were inexpensive to purchase and to mail. They provided professionally photographed snapshots of interesting sights, events, locations, and even people. They could be scenic or decorative, realistic or imaginative, whimsical or sentimental.

By virtue of their very size, postcards allowed only a concisely worded message, making them the ideal vehicle for those who detested letter-writing but were nonetheless obliged to make contact. Although their use is less prevalent today than in previous years, postcards still record the landscapes that surround us. They preserve images of the events that matter to us. They continue to tell the stories of our lives.

It seems as though Florida has been a tourist destination forever. Over the years, visitors from every state in the country and practically every nation in the world have come to the Sunshine State. Many of them traveled as far south as they could possibly go, all the way to Key West. Others stopped along the way in the smaller communities of the Florida Keys. Through the postcards that they sent home to friends and relatives, it is possible to make that trip with them, to revisit the places that they went and experience the sights that they saw.

More than 800 islands comprise the Florida Keys. Some are very small, barely peeking above the surface of the surrounding water, while others are much larger. Some are uninhabited, except for wildlife. Others are thriving communities, home to thousands of residents and even more visitors. Some are largely undeveloped; others teem with commercial activity. Some can't be reached by automobile, while the connecting bridges of the Overseas Highway link others. While Key West is perhaps the best known of the Florida Keys, it's only part of the story.

Until a wealthy businessman by the name of Henry Flagler pursued his dream of building the Key West Extension of the Florida East Coast Railway, Key West was accessible only by ship. It took nearly seven years, several hundred lives, and approximately $25 million to complete the project. And what a project it was. Although the mainland community of Homestead was less than 130 miles from Key West, the route between the two towns spanned 42 stretches of open water, with 17 miles of viaducts and concrete-and-steel bridges, and 20 miles of causeways built upon fill dredged from the ocean bottom. What had been called "Flagler's Folly" became known as the "Eighth Wonder of the World."

The arrival of that first train on January 22, 1912, meant that Key West was now just a few hours' train ride from Miami. Passengers could spend their vacation in Key West or use the city

as a point of embarkation for steamships bound for Havana, Cuba. They could also stop along the way to enjoy any of the smaller communities of the Florida Keys.

Flagler's railroad also made life easier for permanent residents of the Keys. While the trains brought visitors, they also carried cargo, increasing the availability of commercially manufactured goods and making distant markets more accessible. After the railway proved feasible, Monroe County issued bonds to finance a road with connecting bridges paralleling the railroad between Florida City near Homestead and Key West. Construction began in the early 1920s, and finally, on January 25, 1928, the new Over-Sea Highway opened. Although the road trip required two rides aboard connecting ferries, travel through the Florida Keys was becoming easier.

Nature, however, has a way of playing havoc with the best of plans. On September 2, 1935, a strong hurricane caused extensive damage to the Middle Keys. Even before the storm, the Key West Extension of the Florida East Coast Railway, like many other businesses during the Great Depression, had been experiencing financial setbacks. Although the damage to the line was repairable, the decision was made to close the railroad south of Miami. Its right-of-way and bridges became the roadbed for the new Overseas Highway that opened in 1938. Since then, millions of visitors have traveled that highway through the Florida Keys to the Southernmost City at its end.

That doesn't mean, however, that Key West is the only place in the Florida Keys that is worthy of either a short visit or an extended stay. Far from it! The Keys abound with places to visit and things to do. At almost every small green mile marker along the Overseas Highway, there is something for every taste, interest, or inclination. From dozens of marinas, fishermen can head out to sea to try their luck at bringing home either fresh fish for dinner or just a tale of the one that got away. At Pigeon Key, history buffs can relive the experiences of the workers who built Flagler's Folly—the Overseas Railroad.

Grab a snorkel, fins, and mask and swim with brightly colored tropical fish along the coral reefs at Key Largo's John Pennecamp State Park. Check out the dolphin show at Islamorada. Study the unique botanical specimens at Lignumvitae State Park. Learn about the rehabilitation of sick or injured sea turtles at the Turtle Hospital on Marathon. Encounter the tiny Key deer on Big Pine Island. Don't feed them, though—it's bad for their health.

Imagine being a lighthouse keeper, especially after making the climb to the very top of a historic lighthouse in Key West. Don't miss a chance to explore Fort Jefferson, a 19th-century military fortification located on an island miles from shore. Splurge on a fancy resort or stay at a mom-and-pop motel. Dine on fresh seafood or a Florida lobster just pulled from a trap. Awaken to a glorious sunrise over the Atlantic Ocean. At the end of the day, celebrate a spectacular sunset over the Gulf of Mexico.

In short, enjoy everything that Key West and all the other Florida Keys have to offer. Oh, and by the way, be sure to mail a few postcards to friends and relatives back home.

One

OVER LAND AND SEA

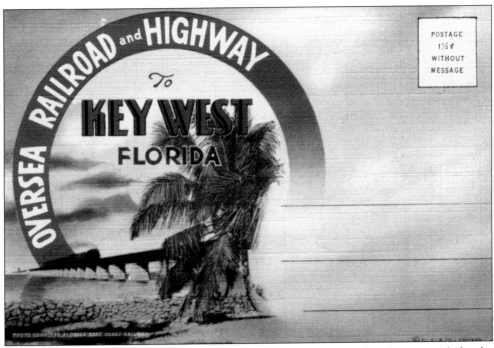

Few places in the world are more idyllic than the Florida Keys, bordered on one side by the Atlantic Ocean and on the other by the Gulf of Mexico. Known as keys, this magical chain of small islands extends nearly 130 miles down the Overseas Highway from the mainland to Key West, geographically the southernmost city in the continental United States. A state-of-mind as much as a reality, the Florida Keys offer something for everyone. (Authors' collection.)

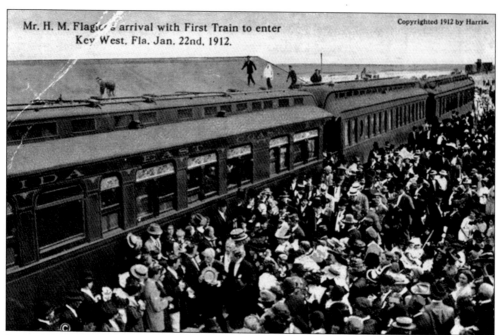

Mr. H. M. Flagler's arrival with First Train to enter
Key West, Fla. Jan. 22nd, 1912.

Copyrighted 1912 by Harris.

For many years, ships were the only means of transportation to link the separate islands. Entrepreneur Henry Flagler changed that with the extension of his railroad from the mainland through the Keys. Construction of "Flagler's Folly" began in 1905 and took nearly seven years to complete. Published in Jacksonville by the H. & W. B. Drew Company, this postcard pictured the train's first arrival in Key West on January 22, 1912. (State Library and Archives of Florida.)

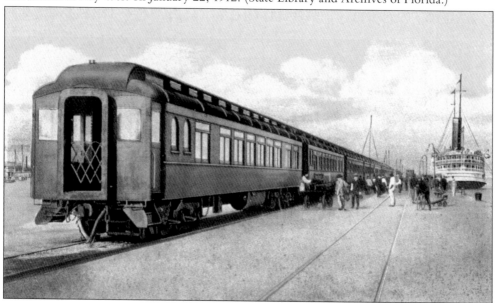

The "railroad that goes to sea" proved to be an economic boon to the Keys. Carrying thousands of passengers annually, the train journeyed through the islands to its final destination in Key West. From the terminal there, travelers could board steamers for the 90-mile trip to Havana, Cuba. Unfortunately Henry Flagler didn't have long to bask in his fame as creator of the "Eighth Wonder of the World"—he died in 1913. (Authors' collection.)

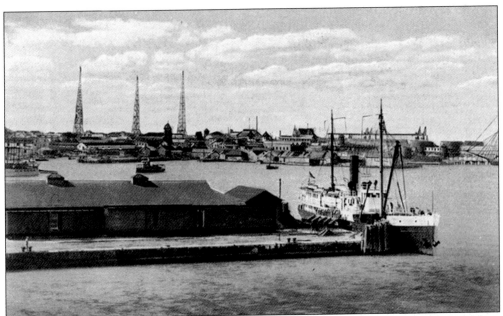

The Key West Extension of the Florida East Coast Railway not only benefited passengers. Flagler's Key West terminal at Trumbo Point, a 134-acre railroad yard created from dredged fill, featured a pier nearly 2,000 feet long. From there, tremendous amounts of cargo moved between Key West and Cuba via large, custom-built ferries capable of transporting a number of freight cars. (State Library and Archives of Florida.)

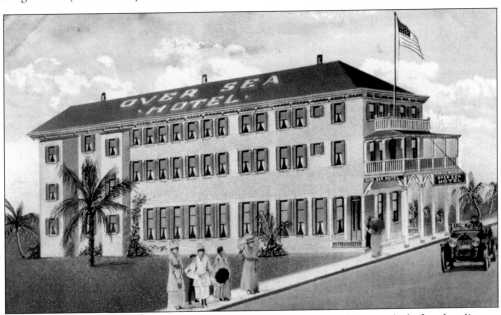

For travelers making an extended visit to Key West or just spending a night before heading to Cuba, the Over-Sea Hotel offered luxurious accommodations. Dated January 20, 1918, this postcard boasted that the "Largest and Only Modern Hotel in the City" had been "Awarded 100 Percent Gold Seal of the State." Located at 919 Fleming Street, it was the "Nearest Hotel to Railroad and Steamboat Station." (Authors' collection.)

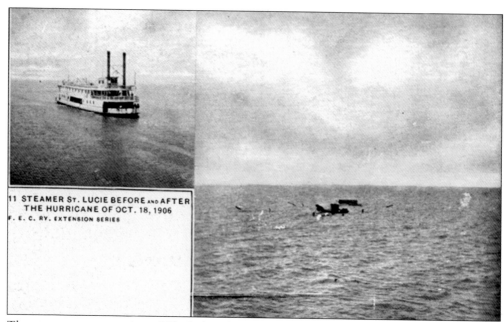

The over-sea construction of Flagler's railroad required a small armada of ships of all types. With their shallow draft, Mississippi River stern-wheelers such as the *St. Lucie* were an excellent choice for work near the island shoals. Constructed in 1888, the *St. Lucie* frequently served as Henry Flagler's flagship. (State Library and Archives of Florida.)

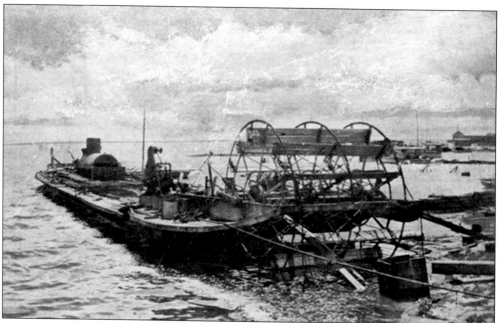

Neither man nor boat was immune to the destructive forces of nature, however. Along with numerous other ships in Flagler's fleet, the *St. Lucie* sank during a major hurricane in October 1906. Over 100 workers also died in the storm that destroyed several miles of railroad track. A century later, the wreckage of the *St. Lucie* rests on the ocean bottom at Biscayne National Park. (State Library and Archives of Florida.)

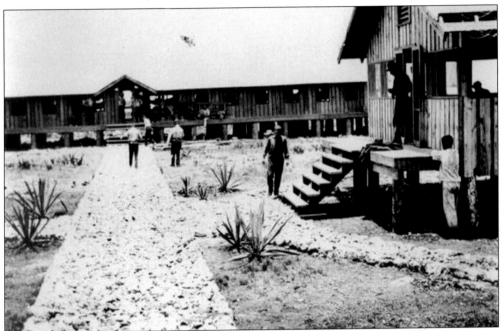

With construction taking place up and down the Keys, Flagler's company erected camps to house the men that were building the railway. The sites also served as storage depots for equipment and materials including supplies of steel, lumber, cement, sand, and fresh water. To ensure large numbers of able-bodied workers, the camps needed to provide decent accommodations. (State Library and Archives of Florida.)

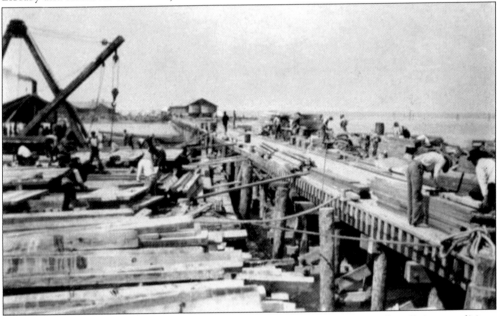

Flagler permitted no alcohol in the construction camps and insisted upon clean living conditions with good, hearty food—an improvement in many of the men's lives. One such camp on Pigeon Key was home for more than 200 workers. It boasted electricity, large bunkhouses, recreational facilities, and an infirmary with medical personnel. (State Library and Archives of Florida.)

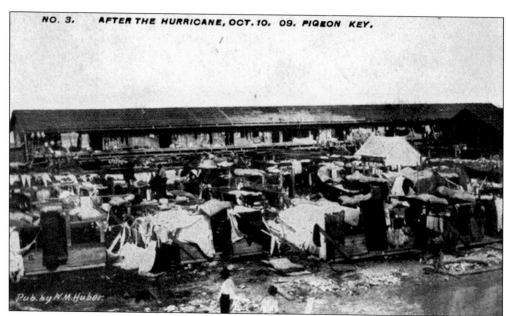

Pub. by N.M. Huber.

During hurricane season, storms were a constant threat to the railroad's progress. The 1906 hurricane wreaked havoc on the Upper Keys. In October 1909, another hurricane bore down with full force upon the Middle Keys. Winds estimated at between 95 and 125 miles per hour did tremendous damage to work already completed. Ships and barges sank to the ocean floor. Miles of railroad track simply disappeared. (State Library and Archives of Florida.)

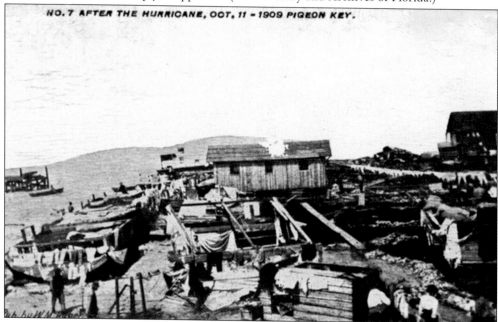

NO. 7 AFTER THE HURRICANE, OCT. 11 - 1909 PIGEON KEY.

Following the 1906 hurricane, Flagler's company instituted additional safety measures and an improved system of communication. These actions undoubtedly helped to reduce the impact of the hurricane that followed three years later. One worker recalled, "We experienced one of the worst hurricanes at our Pigeon Key camp, the center passing over us." Published by Willis M. Huber, this postcard gave credence to his words. (State Library and Archives of Florida.)

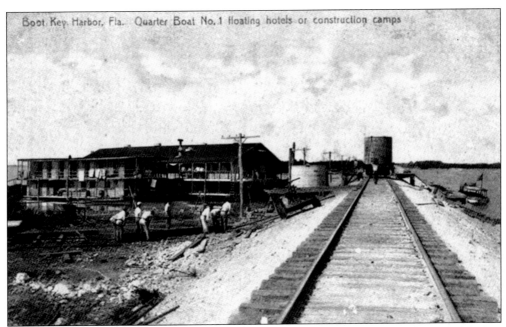

During the early days of the railroad's construction, floating barges provided living accommodations for workers. Some of the vessels were large enough to sleep more than 200 men. After the 1906 hurricane destroyed Quarter Boat Number Four, use of the floating camps or ocean-going dormitories was discontinued for safety reasons. This postcard pictured Quarter Boat Number One at Boot Key. (State Library and Archives of Florida.)

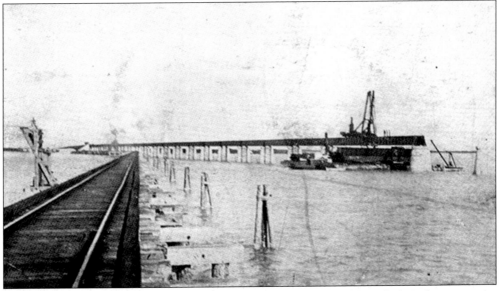

One dilemma facing Flagler's engineers was how to span several miles of relatively open water between Marathon and Big Pine Key. The solution came in four sections of bridges—Knight's Key, Pigeon Key, Moser Channel, and Pacet Channel. When it opened to rail traffic in 1912, the Seven Mile Bridge was touted as the longest continuous bridge in the world. Willis M. Huber published this view of the construction underway at Knight's Key. (State Library and Archives of Florida.)

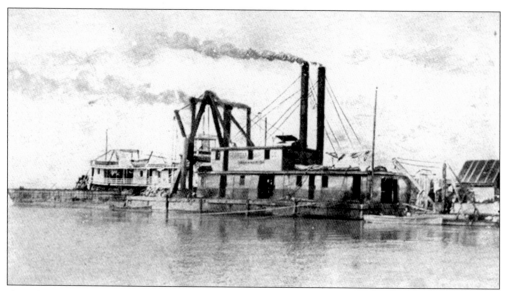

Even large corporations realized the promotional power of postcards. Published by the Florida East Coast Railway Company, this postcard illustrated the work—dredge and fill—of one of the company's suction dredges. Steam-powered dredges dug sand and marl from the ocean floor to make channels. Piled into openings between two small keys, the resulting fill created a single larger man-made island and eliminated the need for a connecting bridge. (State Library and Archives of Florida.)

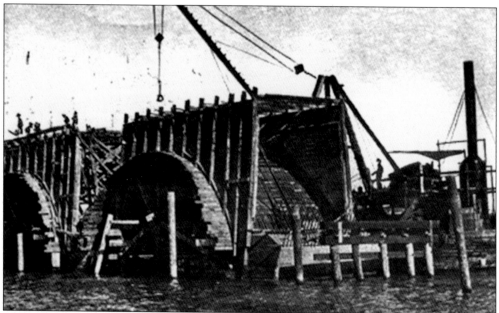

When it came to building the Key West Extension of the Florida East Coast Railway, nothing was simple. Viaducts that consisted of a series of massive concrete arches connected several of the keys. Their construction required the backbreaking labor of hundreds of men, not to mention tremendous amounts of lumber, steel, and cement. Building what many called the "Eighth Wonder of the World" also required a variety of heavy equipment. (State Library and Archives of Florida.)

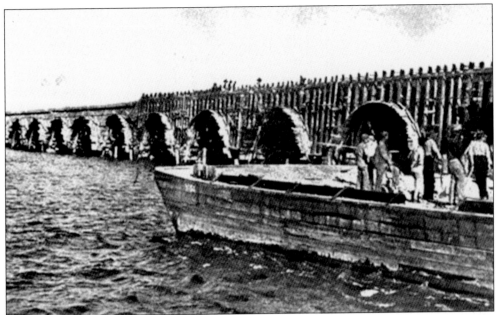

Steam-powered pile drivers worked around the clock to drill holes at varying depths on the ocean floor. Steel posts were then driven into the coral bedrock. Prefabricated wooden forms were erected around the pilings and filled with concrete. An additional set of wooden forms reinforced with steel rods and another layer of concrete completed the process. (State Library and Archives of Florida.)

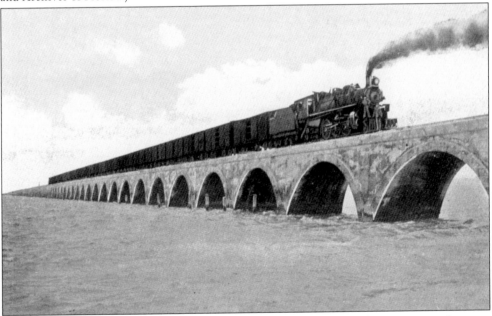

When completed, the Long Key Viaduct, comprised of dozens of arches, was more than two miles long. Rising majestically from the waters of the Atlantic Ocean and Gulf of Mexico, the viaduct quickly became a widely publicized symbol of the railway. Advertisements and timetables, not to mention postcards, featured photographs and paintings of the Long Key Viaduct. (Authors' collection.)

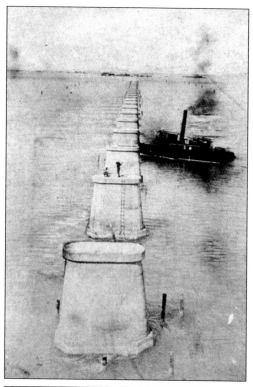

Bridges supported by a series of individual concrete piers spanned gaps between other keys, as shown by this postcard picturing construction of the Knight's Key Bridge. Flagler's workers were usually able to build four piers per week, an impressive-sounding rate. The extent of the task becomes apparent when one realizes that the Seven Mile Bridge required a total of more than 500 concrete piers. (State Library and Archives of Florida.)

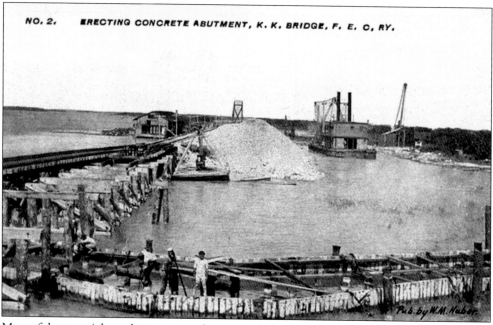

Most of the materials used to construct the railway had to be brought from elsewhere. Other than sand and water, little was available locally. For example, in order to form the concrete used in viaducts, piers, and abutments such as the one pictured in this postcard, water, sand, and gravel were mixed with cement, a powdery substance of burned lime and clay. That cement had to be imported from New York and Europe. (State Library and Archives of Florida.)

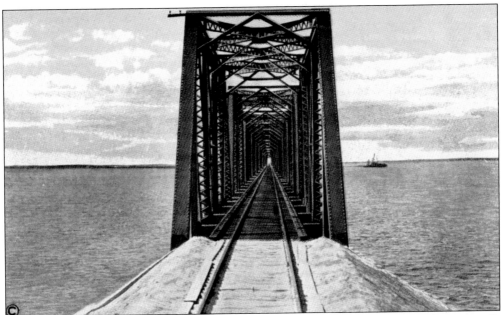

Spanning one of the deepest channels in the Keys presented a major challenge for the railroad's engineers. With water depths of nearly 40 feet, construction of the Bahia Honda Bridge connecting Bahia Honda and Spanish Harbor was almost as difficult as building the much longer Seven Mile Bridge. A distance of approximately one mile required 9 shorter concrete arches and 26 longer spans that rested upon concrete piers. (Authors' collection.)

Railroads require railroad stations, such as this one at Long Key, but that was just the beginning. Along with the stations came maintenance facilities for the railroad and businesses that offered amenities to its passengers. One of 20 postcards contained in a souvenir folio, this image pictured the coconut grove that paralleled the railroad tracks at Long Key. Undoubtedly some enterprising soul was more than willing to sell one of those hard, green coconuts to Yankee visitors! (Authors' collection.)

Prior to completion of the railroad, most of the Florida Keys could be reached only by ship. After Henry Flagler's dream of an "overseas railroad" proved feasible, Monroe County issued bonds to finance a road between the mainland and Key West. Construction began in the early 1920s, and finally on January 25, 1928, the new Over-Sea Highway opened. Utilizing connecting bridges between keys, the roadway offered almost uninterrupted travel for automobiles. Only two stretches of the highway between Lower Matecumbe and No Name Key required a ferryboat ride. These two postcards pictured the northern beginning of the highway near Florida City and the Boca Chica Bridge approaching Key West at the southern end. (Authors' collection.)

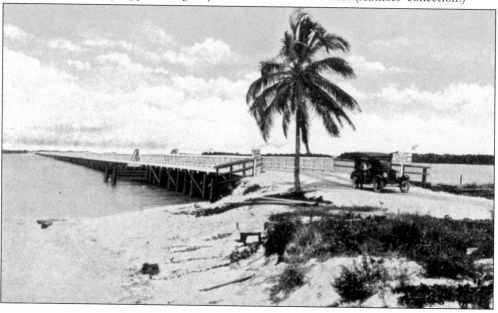

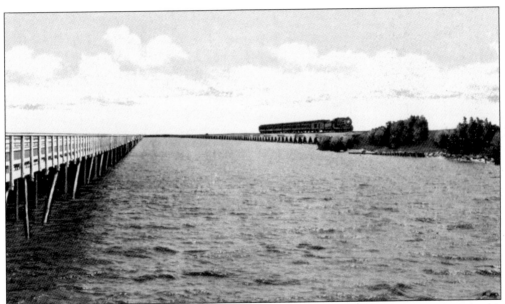

The new highway paralleled the railroad tracks for much of the distance. It doesn't take much imagination to envision rail passengers pointing out their windows at vacationers making their way to Key West by automobile. At the same time, countless numbers of children undoubtedly waved from the back seats of their parents' cars, urging the train's engineer to blow his whistle. Such idyllic scenes wouldn't last much longer, however. (Authors' collection.)

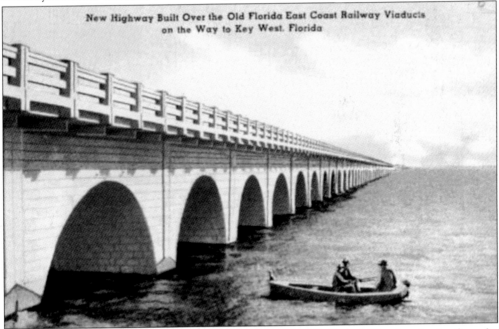

On September 2, 1935, a devastating hurricane hit the Middle Keys, killing hundreds of people. The Key West Extension of the Florida East Coast Railway suffered extensive damage. Already in dire financial condition, the company decided to close the line south of Miami. As the caption on this postcard indicates, much of the roadbed and many of the bridges and viaducts were repaired and reused in a new project. (State Library and Archives of Florida.)

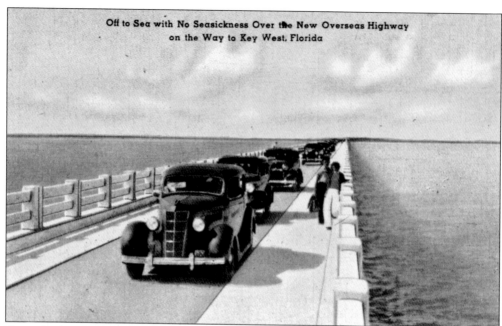

From the destruction wrought by the 1935 hurricane came something quite beneficial to all of the Florida Keys. After the Key West Extension of the railroad closed, federal and state funds were used to purchase the company's bridges, roadbed, and right-of-way. In 1938, with great fanfare, the new Overseas Highway opened. Uninterrupted automobile travel from the mainland to Key West was now a reality. (Authors' collection.)

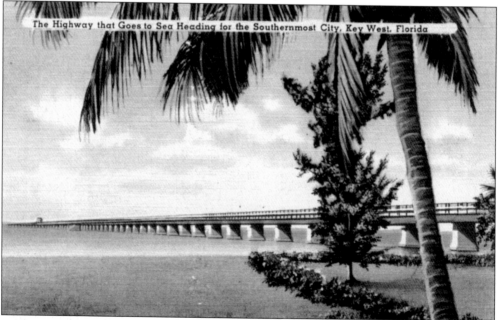

Offering dozens of different views, souvenir postcards made great promotional tools for the new highway. Some touted the alleged health benefits, bragging "Off to Sea with No Seasickness Over the New Overseas Highway on the Way to Key West." Other cards touted "The Highway that Goes to Sea Heading for the Southernmost City, Key West, Florida." (Authors' collection.)

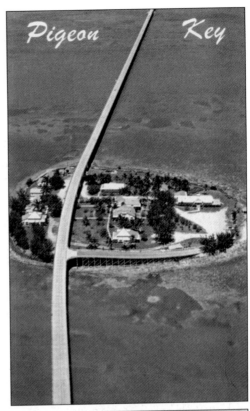

These two postcards offered excellent views of the engineering marvel known as the Seven Mile Bridge on the new Overseas Highway. Extending to the north and south of the tiny, five-acre island of Pigeon Key, approximately 45 miles north of Key West, the span appeared to be a long, slightly curving ribbon of concrete dividing the Atlantic Ocean and the Gulf of Mexico. Photographed by Ed Swift, this aerial view of the bridge as it crossed Pigeon Key was turned into a postcard by Koppel Color Cards of Hawthorne, New Jersey. The second card presents the same scene from the perspective of an automobile driver, a little closer to the road surface, but still high above the water. (Authors' collection.)

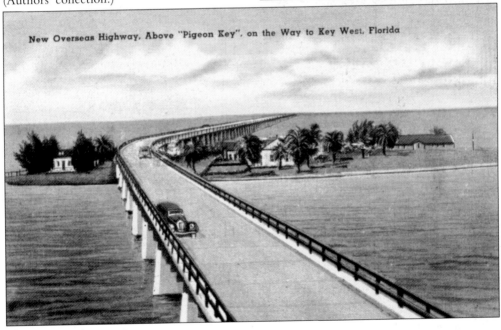

New Overseas Highway, Above "Pigeon Key", on the Way to Key West, Florida

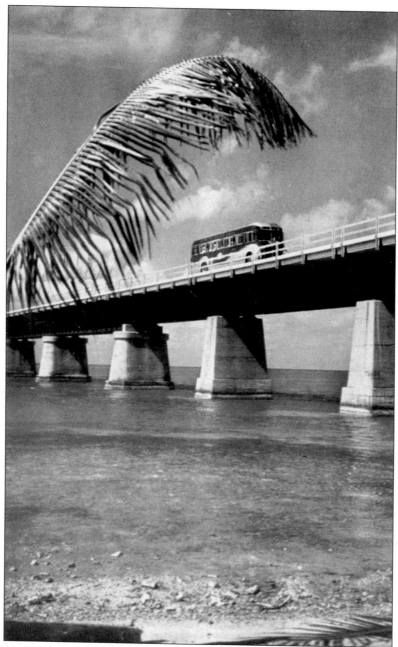

On April 8, 1955, J. S. Faulkners spent 2¢ to mail this striking Mike Roberts Color Production postcard to Mr. and Mrs. Andrew Fletcher in Winnebago, Illinois. He wrote, "Here I am looking at this fantastic view of the 'World Famous Overseas Highway, connecting the mainland of Florida with Key West.' I gather from reading the newspaper that you are still knee-deep in snow." Perhaps Faulkners had just arrived in warm, sunny Key West aboard a silver-and-red bus similar to the one pictured on the postcard. While it might have been unkind of him to "rub it in" to his friends mired in a frigid Northern winter, perhaps this image of a cerulean blue sky, crystal-clear water, and palm fronds swaying in the gentle breeze provided a touch of warmth for the folks back home. (Authors' collection.)

Two

STARTING OUT

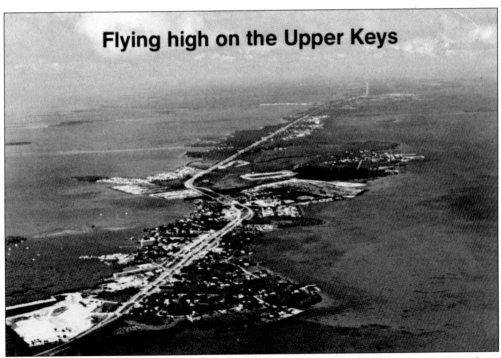

Flying high on the Upper Keys

During the 1970s and 1980s, the state replaced some of the narrower bridges and roadway with wider stretches. For much of the distance, however, travelers to Key West still drive the same narrow highway that visitors have used since 1938. Along the edge of the road, small green signs with white numbers hark back to the original mileposts installed along Flagler's railroad. Known as mile markers (MMs), the signs designate locations throughout the Keys. (Authors' collection.)

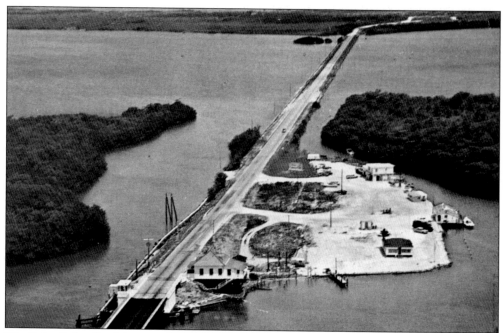

The Palm Color Card Company of North Miami described this aerial view of Jewfish Creek on the Overseas Highway as being "where the Keys meet the mainland." Since the bridge at MM 108 marks the point at which the 18-mile stretch of road from Florida City on the mainland connects with Key Largo in the Upper Keys, that statement is definitely accurate. (Monroe County Public Library.)

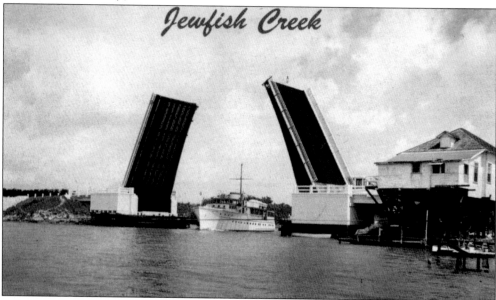

Included in a souvenir folio from the 1960s, this card offered a close-up look at Jewfish Creek's steel drawbridge that opens to allow passage of tall-masted sailing vessels and large motorboats. It fails, however, to show the long lines of traffic that even today continue to back up in both directions along "The Highway that Goes to Sea," better known as the Overseas Highway and U.S. 1. (Authors' collection.)

Cars, pickup trucks with and without attached boats, a large tour bus, and a shiny silver travel trailer filled the parking lot of Tommy's Jewfish Creek Fishing Camp and Seafood Restaurant. Located just south of the Jewfish Creek Bridge, the Key Largo establishment used this postcard published by Hollywood, Florida's Dukane Press to offer "Complete Fishing Facilities." (Authors' collection.)

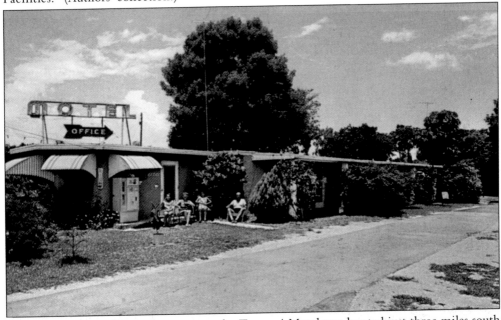

For vacationers needing a place to stay, the Terrangi Motel was located just three miles south of Jewfish Creek. Ethel Wasserman, the resident owner, advertised, "Fine Restaurant on the Property—Enclosed Harbor—Tidal Swimming Pool—Rooms—Efficiency and Family Apartments—Marina with Boat Ramp, Boat and Motor Rentals—Trailer Accommodations—Day, Week or Month." To further ensure a relaxing vacation, she also promised "Pulse-A-Rhythm Mattresses." (Authors' collection.)

Hello from Key Largo

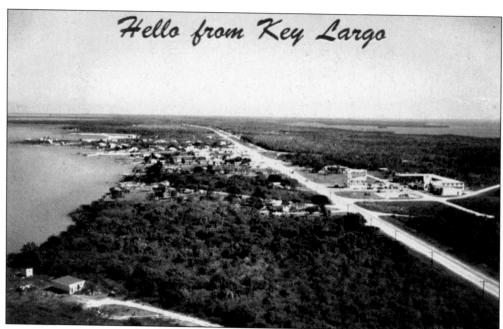

Early Spanish maps recognized it as the largest of the islands, calling it Cayo de Dose Leguas or Key of Twelve Leagues. In subsequent years, both the main community and the post office were known as Rock Harbor. Then along came a Hollywood movie with two very famous stars, Humphrey Bogart and Lauren Bacall. In true entrepreneurial spirit, in 1952, civic leaders cashed in on that fame and renamed the island Key Largo. (Authors' collection.)

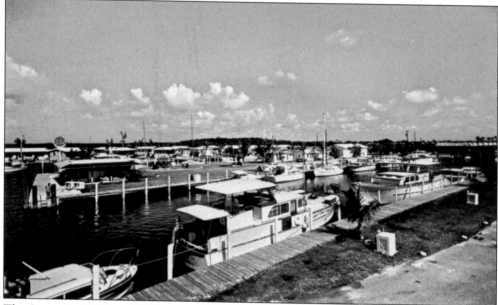

The Ocean Reef Inn and Villas on North Key Largo emphasized the community's strong ties to the water with this postcard. "A mile of broadside docking offers members and guests of Ocean Reef Yacht Club ideal convenience to dockside kitchenette 'yachtels,' and the golf, swimming, dining and complete facilities of fabulous Ocean Reef with deep-sea game fishing, off-shore and in-shore tarpon and bonefishing 15 minutes away." (Authors' collection.)

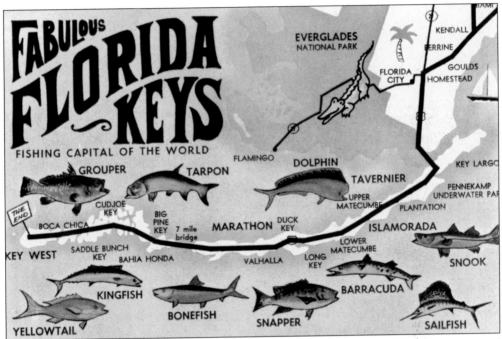

If that water connection hadn't been obvious before, these two postcards made it a virtual certainty. Illustrating all of the types of fish just waiting to be caught by avid fishermen, this postcard published by Murphy Brothers Press raved about the "Fabulous Florida Keys" as the "Fishing Capital of the World." The Rod and Reel Motel reinforced that image by advertising itself as "The Finest on the Keys. Phone Key Largo 3271. A One-Stop Motel. Open year 'round. Located in the heart of the world's best fishing waters. Arrangements made for all Types of Fishing. Where People Come to Stay a Day and Never Want to Go Away." (Authors' collection.)

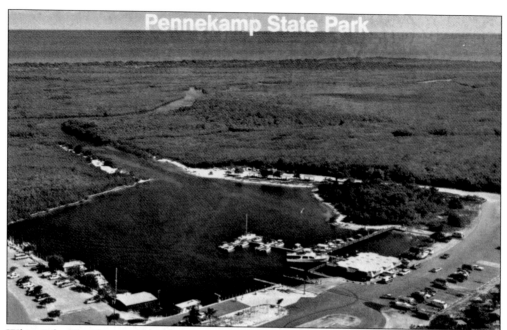

When John Pennecamp Coral Reef State Park was established in 1960, it became the nation's first underwater state park. With approximately 70 nautical square miles of coral reefs, seagrass beds, and mangrove swamps, the park's activities include swimming, snorkeling, picnicking, camping, and fishing. The entrance to this underwater wonderland is located in Key Largo at MM 102.5 on the Overseas Highway. (Authors' collection.)

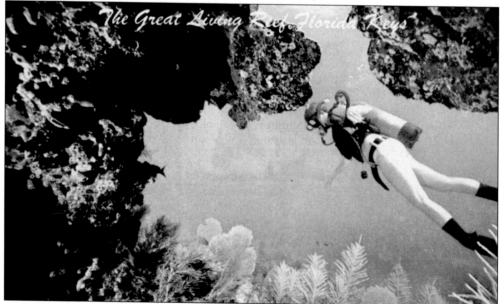

The Great Living Reef Florida Keys

It is for good reason that Key Largo calls itself the "Sport Diving Capital of the World." Contained within John Pennecamp Coral Reef State Park is a portion of the only living coral reef in the continental United States. Published by Promotion Products Company of Marathon, Florida, this postcard offered landlubbers a glimpse of a scuba diver exploring the aquatic majesty of the reef in the crystal-clear waters of the Florida Keys. (Authors' collection.)

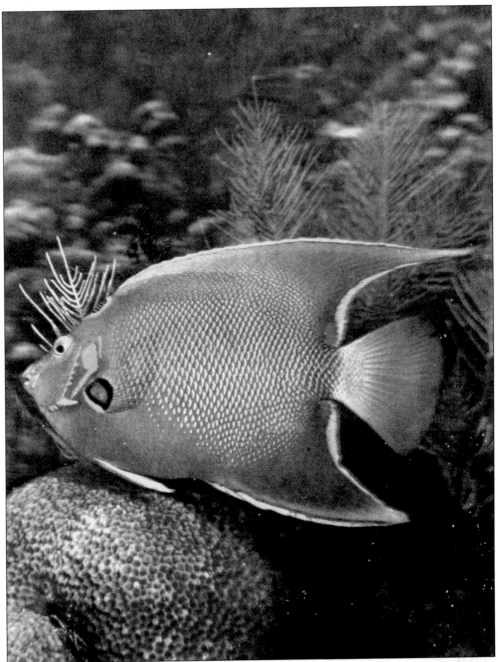

According to the Florida Park Service, a coral reef is comprised of "skeletal remains of corals, other animals and plants that have been cemented together by limestone secretions and calcareous algae." Upon that base, generation after generation of new coral polyps grow. As it increases in size, the reef offers a protective shelter for a large assortment of marine creatures, such as sponges, rays, jellyfish, anemones, crabs, worms, snails, and even lobsters. Along with a large variety of brightly colored tropical fish, such as the angelfish photographed at John Pennecamp Coral Reef State Park for this postcard, the reef is also home to several kinds of grouper, snapper, and mackerel, as well as the occasional barracuda. (Authors' collection.)

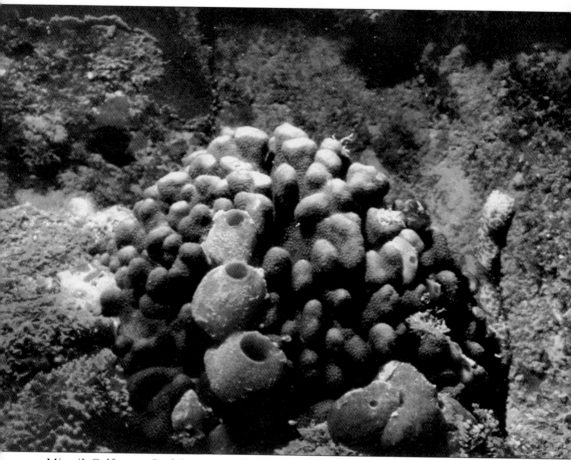

Miami's Gulfstream Card Company published this underwater image of sponges living on the reef formation at John Pennecamp Coral Reef State Park. Although appearing very rugged, a living reef is extremely delicate and is easily damaged by pollutants. Careless boaters and unthinking divers who touch, collect, or inadvertently step on the fragile coral are also responsible for the destruction of this underwater treasure. A vital part of our marine environment, coral reefs, along with mangrove and seagrass habitats, are the breeding grounds for an estimated 70 percent of the catches of commercial fishermen. With more than 1,000 species of fish in the Florida Keys, it's not difficult to realize the importance of protecting the vital marine ecosystem of the coral reef. (Authors' collection.)

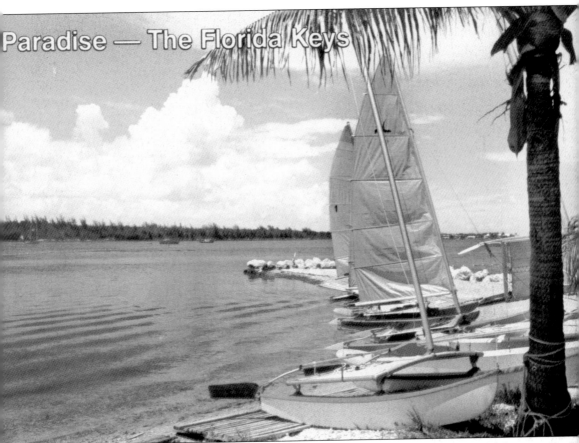

Paradise — The Florida Keys

Published by Keys Color Graphics of Key West, a photograph taken by Charles and Joann Jordon at Pennecamp State Park graces the front of this relatively contemporary postcard titled "Paradise—The Florida Keys." On the reverse side the caption poses the question, "Who could ask for more? Sky of the purest hue, water of the clearest blue, palms waving in the breeze, a boat to sail the seas." (Authors' collection.)

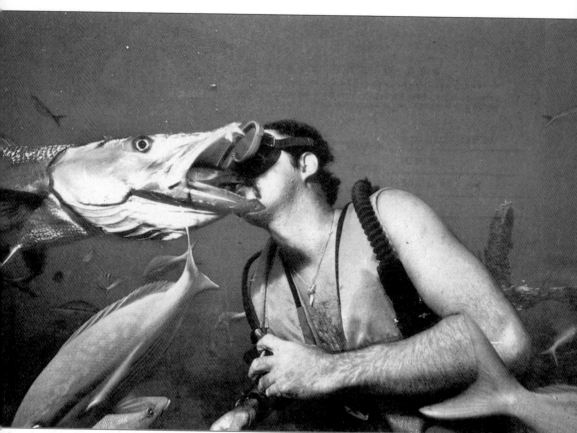

Why would anyone stick his face in the mouth of a hungry barracuda? According to this postcard, Capt. Spencer Slate of the Atlantis Dive Center could answer that question as he and his pal Oscar the Barracuda entertained visitors. Located at MM 106.5, the center also offered dive trips that included a frolic with a moray eel or the opportunity for an underwater wedding in front of the *Christ of the Deep* statue at Key Largo Dry Rocks. (Authors' collection.)

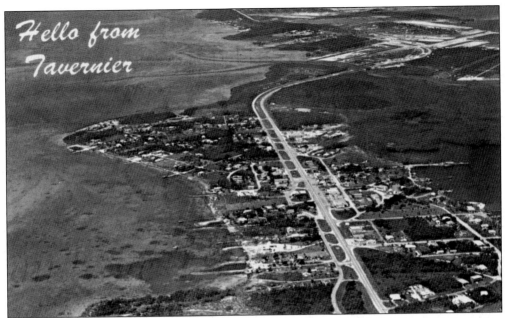

Hello from Tavernier

One of the oldest towns on Key Largo, Tavernier is located between MM 92 and 85. Settled in the 1860s by Bahamian farmers from Key West, the fishing and farming community became a pineapple and coconut plantation after the arrival of Flagler's railroad. A number of historic structures still offer a view of life in earlier days. (Authors' collection.)

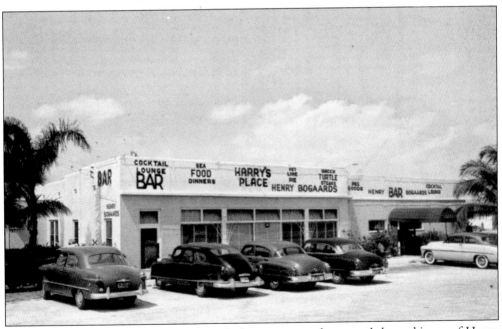

Dating from the 1950s, this Genuine Kodachrome postcard captured the ambiance of Henry Bogaards's establishment. According to the postcard, the cocktail lounge and restaurant specialized in "Sea Food, Stone Crabs, Green Turtle Steaks, and Chops." For the frugal traveler, Harry's Place offered a "$1.00 Special Full Course Dinner." Judging from the number of cars lined up out front, the menu was quite popular. (Authors' collection.)

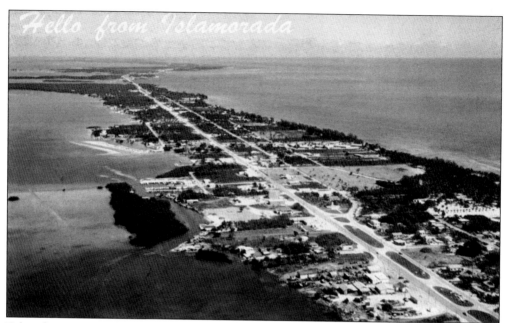

Taken from souvenir folios of the 1960s, these two postcards offer a bird's-eye view of Islamorada with the Atlantic Ocean to its east and waters of Florida Bay and the Gulf of Mexico to the west. Islamorada, a name derived from the Spanish words for purple isles, is pronounced I-lah-mor-AH-dah. Extending approximately from mile marker 90 near Key Largo to mile marker 73, the area encompassed by the community includes Upper and Lower Matecumbe, Windley, and Plantation Keys, as well as the offshore Lignumvitae and Indian Keys. History buffs may enjoy learning about the Native Americans, Spanish seafarers, Bahamian farmers, salvagers, and homesteaders that came to the area over the years. Nature lovers may want to explore the unique botanical aspects of the 280-acre Lignumvitae Key, with its virgin tropical forest. (Authors' collection.)

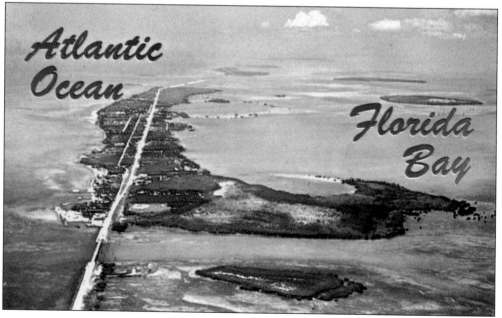

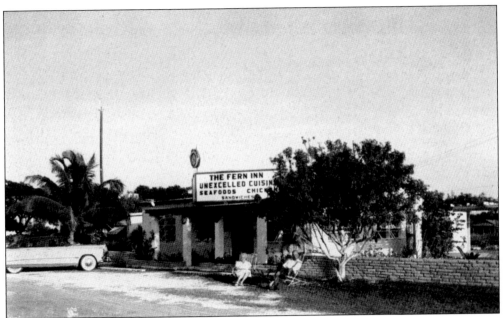

Still others will be drawn to the area for a different reason—the fishing. Owned and operated by Capt. Ed and Fern Butters, the Fern Inn was located 78 miles south of Miami "In the heart of the best Bonefish Grounds." Undoubtedly Captain Ed would happily serve as a fishing guide. For the hungry traveler, the establishment also promised "Unexcelled cuisine—Sea Foods—Steaks—Chicken—Chops." (Monroe County Public Library.)

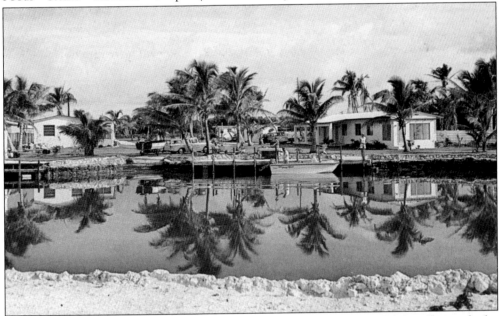

Florida's Palms Resort couldn't have had a more perfect name. In a state with millions of palm trees, a couple by the name of Capt. Walter and Jane Florida owned the "Nine beautiful, completely furnished air-conditioned apartments on the ocean, with swimming—beach—shuffleboard—all in a tropical setting." Capitalizing on Islamorada's fishing reputation, the complex advertised the "World's finest fishing at your front door." (Monroe County Public Library.)

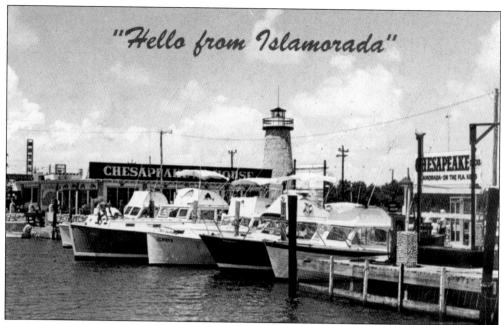

"Hello from Islamorada"

It is for good reason that Islamorada lays claim to the title of "Sport Fishing Capital of the World." Winston Churchill, Herbert Hoover, George Bush, and Al Gore are among the famous fishermen that have come to Islamorada to try their luck at catching the big one—a challenge they have shared with thousands of less well-known anglers. Postmarked July 5, 1968, this postcard pictured the charter boat docks at Islamorada's Whale Harbor. (Authors' collection.)

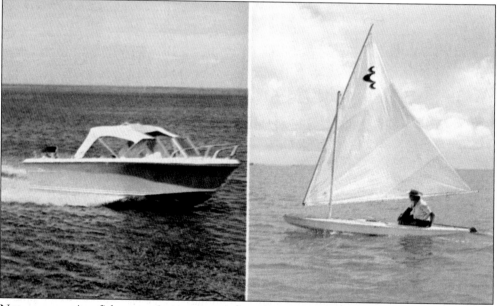

Not everyone is a fisherman, but many people still find pleasure in spending the day on the crystal-clear waters surrounding Islamorada. For those visitors, there are plenty of other aquatic adventures to enjoy. Keys Boat Rentals used a postcard published by Dukane Press to illustrate two of the choices available for "Sailing and boating on Gulf or Atlantic in Beautiful Florida Keys." (Authors' collection.)

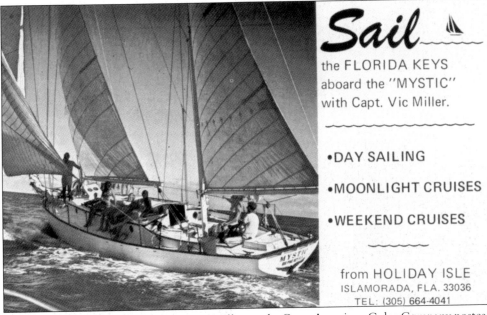

Setting sail from Holiday Isle, Capt. Vic Miller used a Great American Color Company postcard to invite tourists to "Cruise Aboard the *Mystic*. Day sailing and moonlight cruises for parties of six. Eight to ten-day cruises to Dry Tortugas in parties of four." For an alternative kind of maritime experience, the *Aqua-View* sailed from the Chesapeake Dock in Islamorada. The glass-bottomed boat offered tours of sunken Spanish galleons, fish and plant life, and portions of the living coral reef that runs parallel to the Keys. (Authors' collection.)

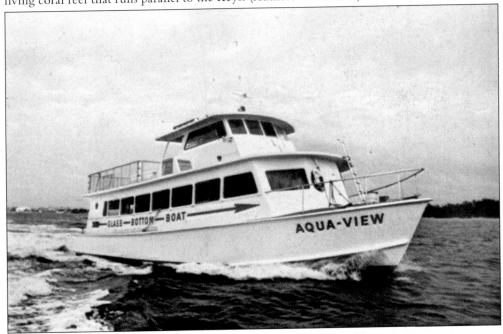

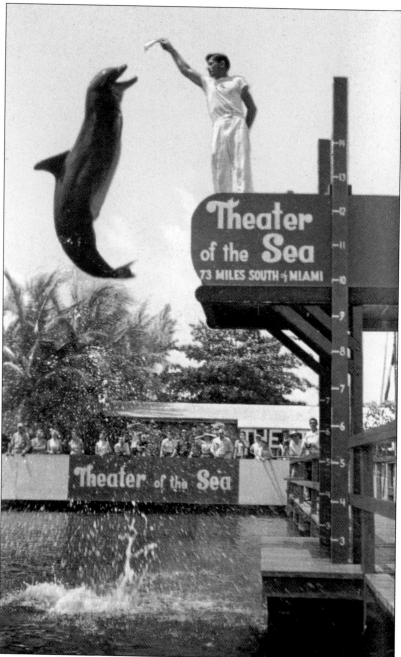

Islamorada also allowed visitors to enjoy dolphins, sea lions, stingrays, sea turtles, and other marine life while standing on dry land. Built at MM 84.5 on the site of quarries dug during construction of the railroad, Theater of the Sea has been providing family fun since 1946. Every year, thousands of tourists have watched a dolphin leap high into the air to snag a fish carefully extended by a trainer, as illustrated by this postcard. A combined entertainment/educational experience, the park in recent years has offered opportunities for more participatory activities. For a fee, visitors may swim with trained dolphins or sea lions in an enclosed lagoon. Also available is the chance to take part in a "dolphin-trainer-for-a-day" program. (Authors' collection.)

"Still here and enjoying every day," read the message on this postcard mailed on April 12, 1956. Located just behind the Islamorada Post Office, this beach scene wasn't always so peaceful, however. According to the caption on the postcard, "This beach was swept clean by the hurricane of 1935, but has now been restored to its natural beauty." (Monroe County Public Library.)

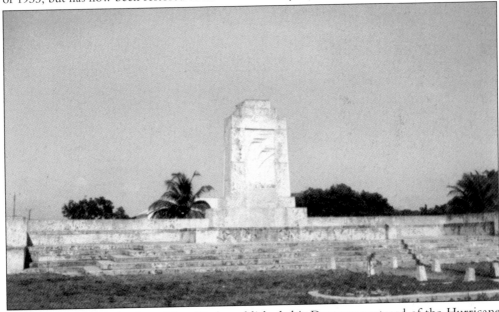

Dexter Press of Pearl River, New York, published this Dextone postcard of the Hurricane Monument at Islamorada. When the Labor Day 1935 hurricane hit the Florida Keys, its winds were estimated at nearly 200 miles per hour. Hundreds of people drowned in the ensuing storm surge. Carved from local coral limestone by Works Progress Administration craftsmen in 1937, the monument commemorating the victims is listed on the National Register of Historic Places. (Authors' collection.)

It cost just a dime in 1974 to mail a Florida Natural Color souvenir folio that contained 13 cards plus this view described as "Fisherman's Favorite Spot." Inside the folder, the copy read, "Driving over the Overseas Highway known as the 'Highway that goes to Sea,' one can see why this is the eighth wonder of the world. Along the highway many beautiful small islands, called keys, have been converted to fishing resorts, exciting attractions, and lovely residential areas." (Authors' collection.)

Miami's Dynacolor Graphics published this waterside view of a spectacular sunset in the Florida Keys. The postcard advertised the Islander, a 114-room motel located at mile marker 82.1 on the Overseas Highway, and gave visitors an idea of the relaxing pleasures awaiting guests at an establishment that claimed to be "Still The Most Unusual Resort in Florida." (Authors' collection.)

The Islander also promoted itself with these two postcards by the same publisher. Appealing to nature lovers suffering through icy winters up North, the cards pictured a red-bellied woodpecker and an American egret. Although populations may have diminished elsewhere, birds of all types can still be seen in the Keys today. Sharp-eyed bird-watchers are likely to spot dozens of species, including brown pelicans, white pelicans, frigate birds, cormorants, herons, roseate spoonbills, ibis, and osprey. The lucky ones might even glimpse a bald eagle! And of course, there are the ubiquitous seagulls that always seem to appear just when visitors are enjoying a light repast along the water. (Authors' collection.)

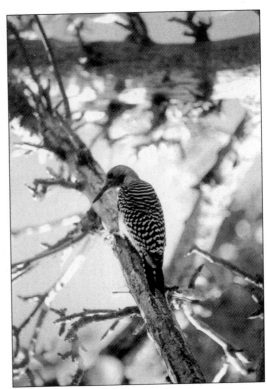

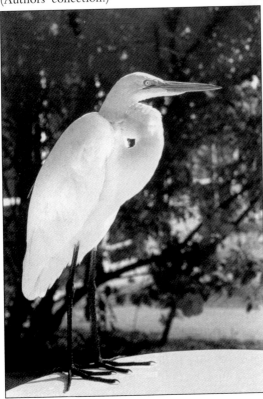

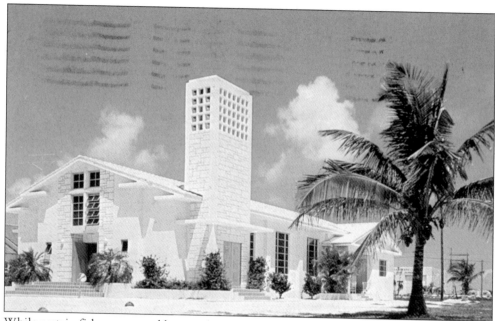

While certain fishermen would argue that a day on the water catching a big fish was a spiritual experience, some residents of the Keys took the idea more literally. Dated 1962, this postcard of the Matecumbe Methodist Church assured visitors as well as parishioners that the church was always open for prayers and meditation. Looking quite modern for the era, the church was built in 1957. (Monroe County Public Library.)

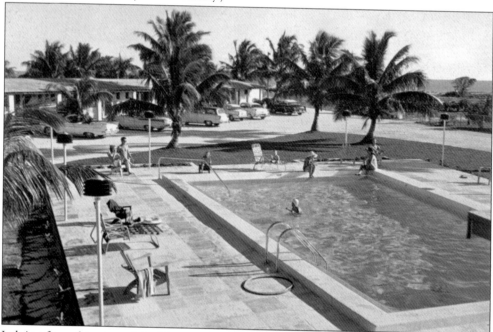

Judging from this view of the Matecumbe Motel on Lower Matecumbe Key, the pool was the place to be. The card advertised, "A deluxe motel resort in a tropical setting on the Ocean. The place to fish and relax. Safe sandy beach, 600 ft. fishing pier, boats, boat ramp, tiled swimming pool, barbecue and picnic tables. Heated and air conditioned." (Authors' collection.)

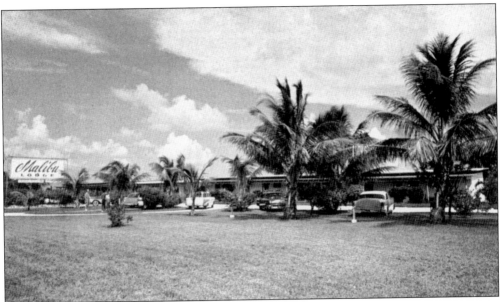

The owners of the Malibu Lodge Motel went even further when they promised guests, "A resort directly along ocean. Beautiful vacation spot which has everything for your enjoyment. Docks, boats, and motors. Large salt-water tide pool. Shuffleboard, barbecue, picnic tables, shelter houses. Restaurant and charter boats across highway." Built in 1951, the Malibu was the first motel built on Lower Matecumbe Key. (Monroe County Public Library.)

On July 21, 1963, Crystal sent this postcard of the Malibu Lodge to her friend Mary in Detroit, Michigan. "I took a 3-day trip last week with some friends to Key West and had a wonderful vacation. Stayed at this motel 2 nights and had saltwater swims. This was the view from our windows of the Atlantic Ocean." Apparently Crystal took full advantage of that saltwater pool. (Authors' collection.)

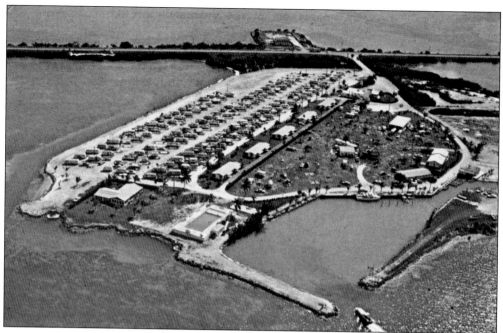

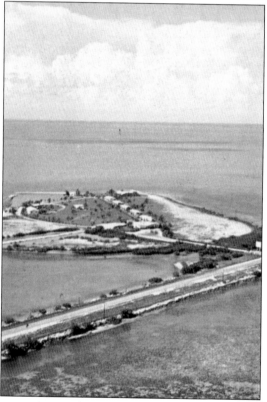

"Fiesta Key Is The Place To Be," proclaimed this postcard that pictured hundreds of Airstream travel trailers and other campers at the Fiesta Key Resort. Connected by a causeway to U.S. 1 at MM 70, the resort offered a motel, pool, store, restaurant, and nearly 300 campsites. Originally called Jewfish Bush Key after a large member of the grouper family of fish, the island was purchased in 1947 by the Greyhound Bus Company. Renamed Tropical Key by the bus line, the island, with its $150,000 bus terminal and restaurant for passengers traveling between Miami and Key West, soon became known more appropriately as Greyhound Key. When Kampgrounds of America (KOA) purchased the island in 1966, Greyhound Key underwent another name change to become Fiesta Key. (Monroe County Public Library and Authors' collection.)

Three

IN THE MIDDLE

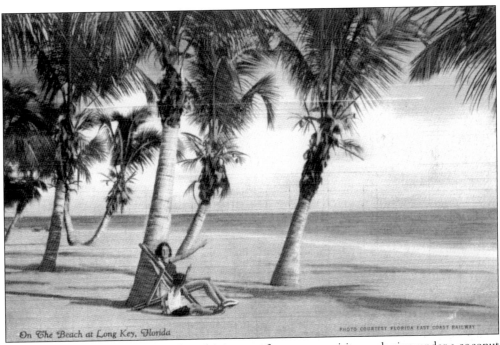

On The Beach at Long Key, Florida PHOTO COURTESY FLORIDA EAST COAST RAILWAY

What could say "Florida" better than this image of two young visitors relaxing under a coconut palm tree on the beach at Long Key? Obviously that was the thinking of the Asheville Postcard Company when they chose this image for the cover of a souvenir folio. Although some consider Long Key to be part of the Upper Keys while others place it firmly in the Middle Keys, all can agree that its current appellation is far more attractive than the early names of Viper or Rattlesnake Key. (Authors' collection.)

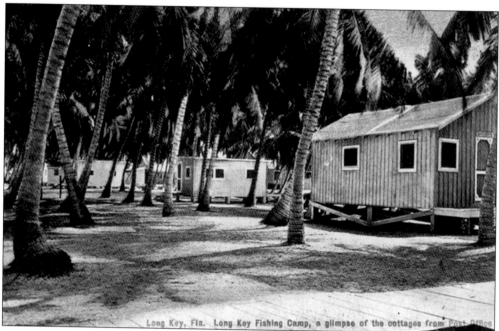

Long Key, Fla. Long Key Fishing Camp, a glimpse of the cottages from Post Office

In the era of Henry Flagler's railroad, Long Key served as home to nearly 1,000 employees, many of whom were working on the Long Key Viaduct. Following completion of the viaduct, the construction camp became the Long Key Fishing Camp, complete with a hotel and a number of smaller cottages. On February 18, 1910, the Key West *Citizen* described activity at the Long Key Fishing Camp by saying, "Mackerel and king fish are plentiful; so are the tourists." Famous visitors included Andrew Mellon, William Hearst, Herbert Hoover, and Franklin Roosevelt. In 1917, author Zane Grey founded the Long Key Fishing Club and served as its first president. After the 1935 hurricane destroyed much of the camp, the club was disbanded. The camp was later rebuilt, and the club reactivated until its land was sold to become Long Key State Park. (State Library and Archives of Florida and Authors' collection.)

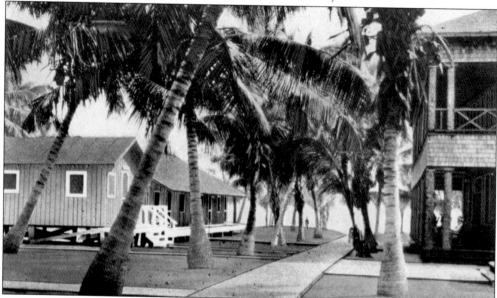

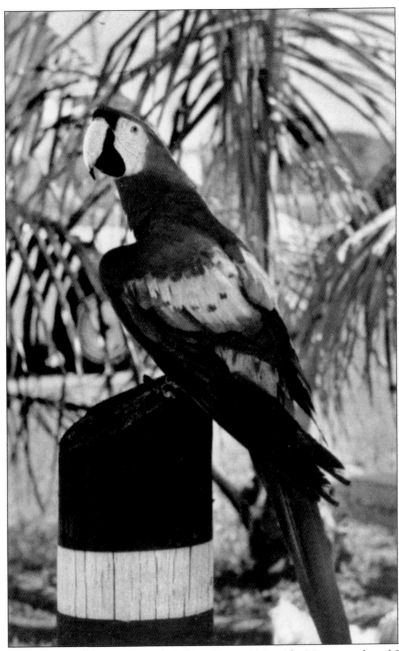

Following World War II, Miami grocer Del Layton and his wife, Mary, purchased Long Key. Using surplus military barracks from Camp Blanding in northern Florida, Layton rebuilt the old fishing camp into what eventually became Layton's Long Key Fishing Club. September 18, 1963, saw the incorporation of the Long Key community of Layton, named for the entrepreneur. The Lime Tree Bay Resort was also located in Layton. Pictured on this Dynacolor Graphics postcard was Mickey, a scarlet macaw. One of 17 tropical birds residing at the resort, Mickey was famous for greeting guests with a cheery "Hello." According to the postcard, the December 1977 issue of *Better Homes and Gardens* featured an extensive article describing the hotel, as well as Mickey's antics. (Authors' collection.)

Conch Key sits just to the southwest of Long Key. Published by Flagler Fotoshop of Homestead, Florida, this real-photo postcard offered a bird's-eye view of the development on the approximately 16-acre island. It also showed just how vulnerable the wooden residences, docks, and few commercial establishments were to rising water caused by storms. (Authors' collection.)

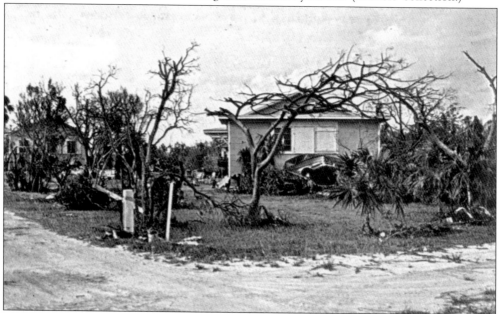

Hurricane Donna inflicted extensive damage on the local area. The category-four storm hit the Middle Keys on September 10, 1960, with sustained winds of 128 miles per hour and storm surges of up to 13 feet. By the time the storm reached Canada, it had caused $387 million in damage and numerous deaths. Donna is still the only storm to produce hurricane-force winds in Florida, the Mid-Atlantic States, and New England. (Authors' collection.)

Lobster Traps in the Florida Keys

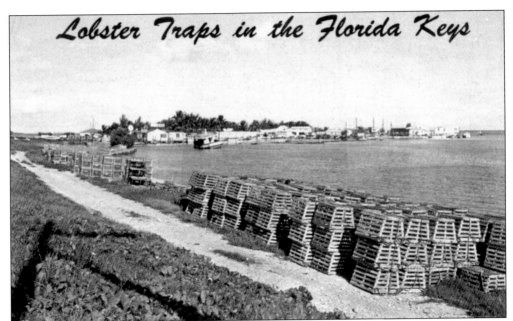

Visitors often wonder about the piles of wooden boxes stacked alongside the Overseas Highway. Not produce crates, they are traps used to capture that elusive crustacean, the Florida spiny lobster, during a commercial season that runs from early August until late March. Thousands of avid non-professionals turn out to dive for the delicacy during a brief sport lobster season that takes place on the last consecutive Wednesday and Thursday in July. (Authors' collection.)

Bryan W. Newkirk purchased Duck Key in 1951 and began its conversion into a 400-acre island community that featured a variety of multicultural elements. This postcard illustrated the West Indies–style architecture of Duck Key's administration building. The lobby had floor tile imported from Cuba, as well as French Provincial and Spanish furniture and decoration. Venetian-style bridges connected the five small islands that made up the "residential, motel, apartment and business center development complete with a yacht harbor and 9-hole golf course." (Monroe County Public Library.)

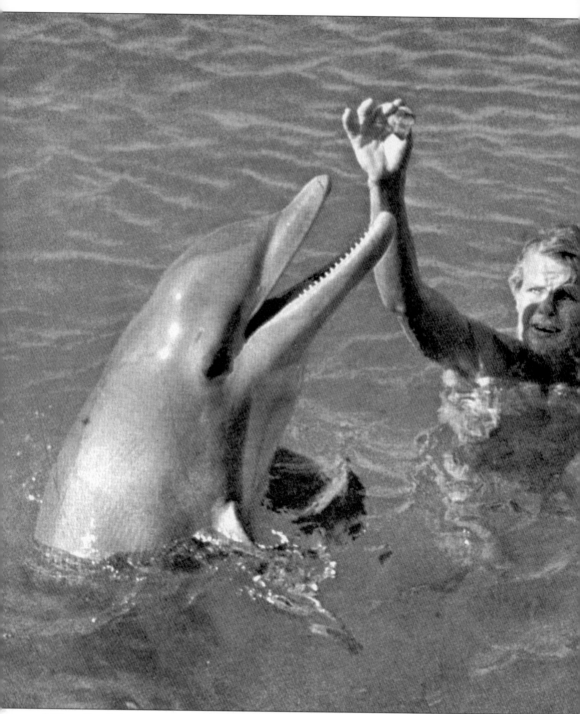

Milton Santini was a pioneer in dolphin management and training. To research the unique abilities of dolphins, he opened Santini's Porpoise School on Grassey Key. In 1962, a Hollywood studio capitalized on the affection people feel for the gentle creatures when it chose the school as the location for a new movie. *Flipper* featured five of Santini's dolphins; his first pupil, a dolphin named Mitzi, starred in the title role. Located at MM 59, the successor to Santini's

Porpoise School, the non-profit Dolphin Research Center, offers visitors the opportunity to learn more about dolphins, as well as to engage in interactive swim programs. Mitzi, the original "Flipper," is buried on the facility's grounds, her grave marked by a commemorative plaque. (Authors' collection.)

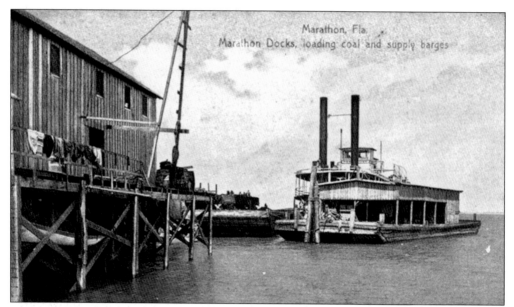

Located on Key Vaca, the largest of the Middle Keys, Marathon has always had a strong commercial aspect. Published by the Hugh C. Leighton Company of Portland, Maine, this early postcard provided a close-up view of coal and supply barges being loaded at Marathon's docks. According to local lore, the name Marathon was derived from the rapid pace at which Henry Flagler urged completion of his railroad to Key West. (State Library and Archives of Florida.)

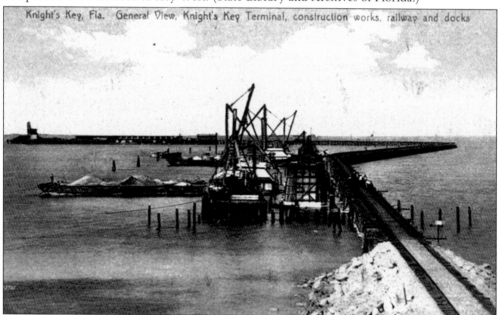

Knight's Key, located at mile marker 47, was also important in the transportation history of the Keys. At one point, Henry Flagler envisioned Knight's Key, complete with a deepwater port, as the ultimate destination of his Florida East Coast Railway. By February 1908, travelers from Miami could take the train as far south as Knight's Key. Passengers then transferred to Flagler's Peninsular and Occidental Steamship Company vessels bound for Cuba. (State Library and Archives of Florida.)

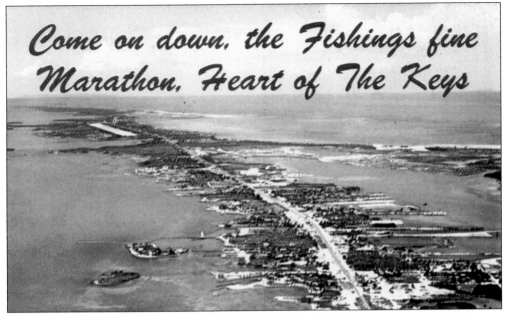

Come on down, the Fishings fine Marathon, Heart of The Keys

On the top postcard, Marathon advertised itself as "the heart of the Keys" and invited visitors to enjoy the sport fishing for which the area was and still is famous. At the same time, commercial shrimp boats visible in the foreground of the lower postcard represented another aspect of the maritime industry. Both of the postcards offered aerial views of Marathon during an era when the community was changing dramatically. During the 1950s, 1960s, and 1970s, dredging made tremendous growth not only a possibility but also a reality. Incorporated in 1999, Marathon is considered the business center of the Middle Keys, with motels, restaurants, small local stores, national retail chains, and even a commercial airport. (Authors' collection.)

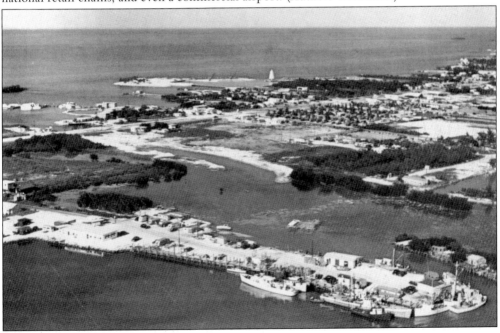

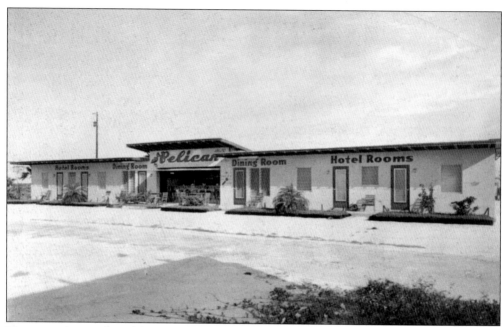

Years ago, just as they do today, winter visitors, also known as "snowbirds," needed a place to stay. So did the summer tourists, not to mention those who traveled to the Keys during the spring and fall. Located 12 miles north of Marathon, the Pelican Motel used this Genuine Natural Color postcard to advertise, "Clean modern rooms—good home-cooked food—pleasant surroundings—excellent fishing." What more could a visitor want? (Authors' collection.)

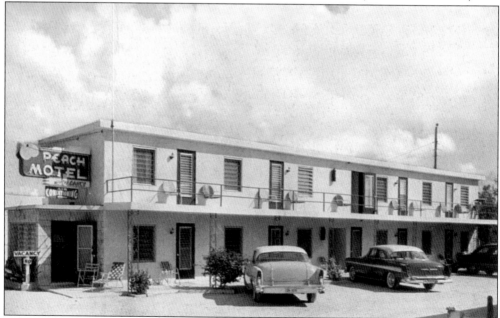

On April 4, 1964, someone named Floss sent her aunt in Pittsburgh the following message, "It's a very warm day—so many things to do. I leave for home in about two weeks. I dread the drive. It's such a long way!" Her postcard came from Marathon's Peach Motel, owned and operated by who else but Mildred and Herman Peach. (Authors' collection.)

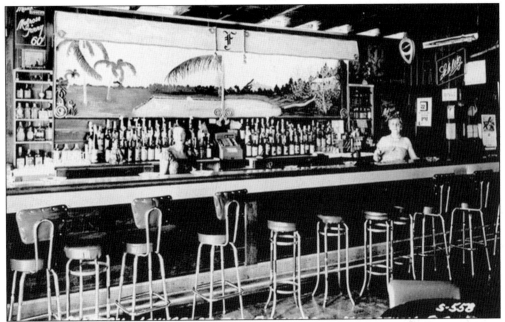

Plain or fancy, inexpensive or pricey—there was something for every taste, wallet, and palate when it came to being "wined and dined." During the 1950s, Marathon's Flamingo Lounge offered the ideal setting for those who fancied the idea of a cocktail before (or after) dinner. Swiveling barstools, neon beer signs, and a scenic mural of an idyllic Florida beach scene, not to mention two attractive female bartenders, contributed to the ambiance. (State Library and Archives of Florida.)

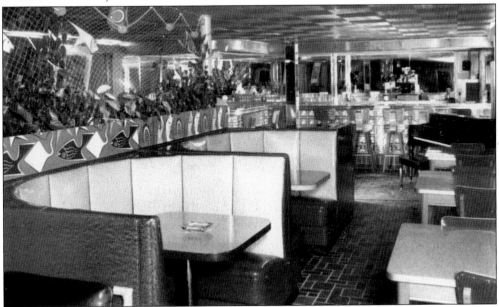

Jon's Crosswinds at Davis Docks in Marathon used a postcard published by Valence Color Studio and dated March 14, 1954, to advertise itself as "The Florida Keys most beautiful Air Conditioned Dining Room and Cocktail Lounge." Perhaps the striking red-and-yellow vinyl booths and matching formica-topped tables were the reason behind that claim. (Authors' collection.)

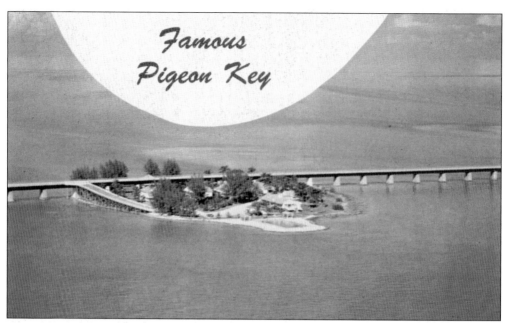

Famous Pigeon Key

Miami's Florida Natural Color, Inc. joined forces with Koppel Color Cards to distribute this view of Pigeon Key. Why did they label it as "Famous?" Perhaps because Pigeon Key (or Cayo Paloma on early Spanish charts) was named for the white-crowned pigeon found in the area. Or maybe it was because of the small island's interesting history as a construction camp for the Key West Extension of Flagler's Florida East Coast Railway. (Authors' collection.)

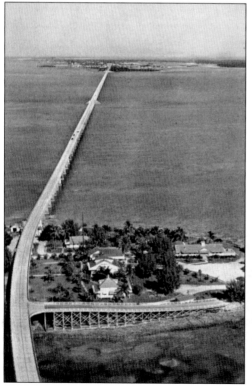

On the other hand, the awesome view of the Seven Mile Bridge as it crossed Pigeon Key and headed off toward the distant horizon might just have been reason enough for the label. This Curteichcolor postcard published by Gulf Stream Card and Distributing Company certainly illustrated that idea to perfection. Faced with an ever-increasing flow of traffic, a new Seven Mile Bridge was completed in 1982, bypassing Pigeon Key completely. (Authors' collection.)

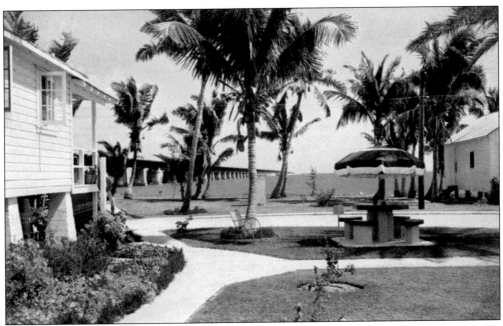

With just a slight detour from the Overseas Highway, however, it's still possible to visit Pigeon Key. From the visitor center at MM 47 on Knight's Key, Pigeon Key is just a short trolley ride or a slightly longer walk away. Visitors can then stroll around the restored buildings shown on these two postcards. Pigeon Key has served first as a construction camp and then a bridge maintenance facility for the railroad, a base for relief efforts during the 1935 hurricane, headquarters for the Overseas Toll and Bridge District, barracks for Coast Guard personnel, and a marine biology station. Listed on the National Register of Historic Places in 1990 and currently staffed by volunteers from the Pigeon Key Foundation, the site is a wonderful way to learn more about life on the island over the years. (Authors' collection.)

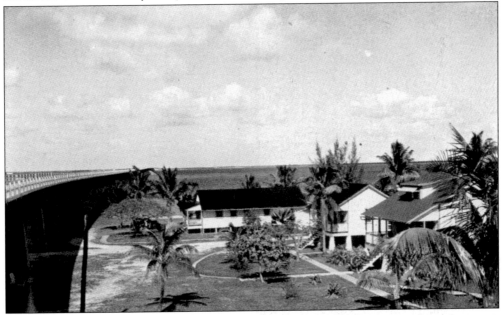

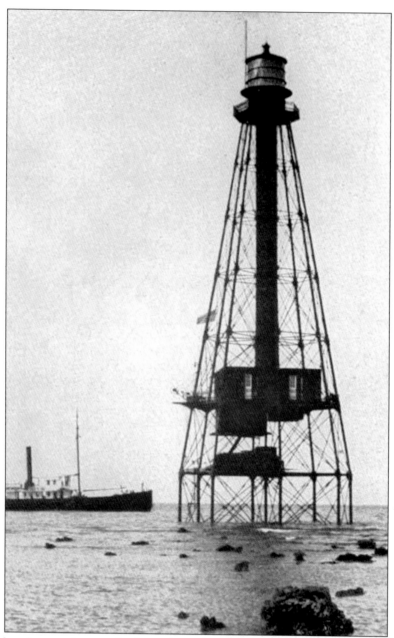

Keen-eyed readers may have noticed something that appears to be a lighthouse in the Marathon postcards pictured on page 55. Built by Floyd Davis in 1952, the structure served as a decorative landmark for the Davis Docks. Still standing on the grounds of Faro Blanco Marine Resorts, the lighthouse contains two suites where resort guests may spend the night. Seven miles south of Marathon and 4.5 miles offshore is the Sombrero Key Lighthouse pictured on this postcard. At 142 feet, the iron-pile lighthouse is the tallest of the reef lights. It was completed in 1858 under the direction of George Meade, who later served as a Union general during the Civil War. The lighthouse was fully automated in 1960 and is still operated by the U.S. Coast Guard. Accessible only by boat and closed to the public, the lighthouse can be viewed from the beach at Sombrero Key State Park just south of Marathon. (State Library and Archives of Florida.)

Four

ALMOST THERE

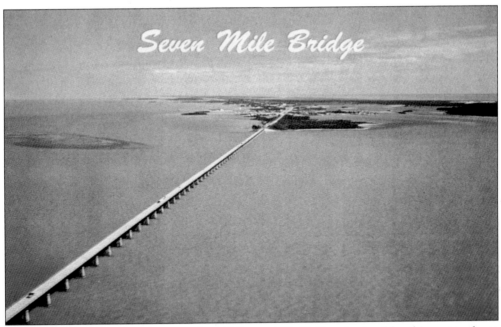

Replaced by a more modern span, the old Seven Mile Bridge depicted by this postcard was partially dismantled and is currently used mostly as a fishing pier. In January 2006, 15 people fleeing Cuba successfully reached a portion of the old span before their boat sank. The migrants, unable to walk to land since several sections of the bridge were missing, had to be rescued by the Coast Guard. Authorities determined that the refugees had not touched American soil and returned them to Cuba. Their case is under appeal. (Authors' collection.)

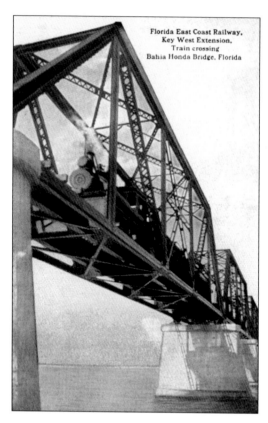

Florida East Coast Railway,
Key West Extension,
Train crossing
Bahia Honda Bridge, Florida

As this postcard showed, the Bahia Honda Bridge on the Key West Extension of Flagler's railway was a much different entity than the other spans travelers crossed on the journey south. The deep water in the channel between Bahia Honda and Spanish Harbor necessitated not only taller pilings for the bridge, but also massive supporting steel girders. The train then ran through the middle of the lacy but extremely strong superstructure. As long as there were no oncoming trains, the narrow span also made a great fishing pier, as evidenced by the real-photo postcard. Or perhaps the fishing foursome only used the bridge as a scenic backdrop for this image that recorded their catch on that day. (State Library and Archives of Florida and Monroe County Public Library.)

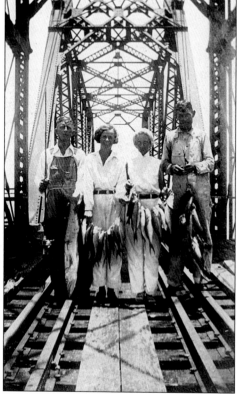

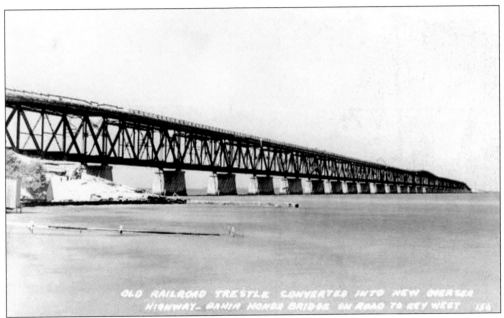

After the 1935 hurricane, when the decision was made to incorporate the undamaged spans of the Florida East Coast Railway into the new Overseas Highway, the Bahia Honda Bridge presented a problem. It was just wide enough to accommodate Flagler's trains, but too narrow for two lanes of automobile traffic. Engineers decided upon an innovative solution to the difficulty. Relying on the massive strength of the steel and concrete framework, the builders constructed the roadbed for the new highway on top of the bridge's steel girders. One of the original spans of the Overseas Highway that was replaced in the late 1970s and early 1980s, the old bridge was listed on the National Register of Historic Places in 1979. (State Library and Archives of Florida and Monroe County Public Library.)

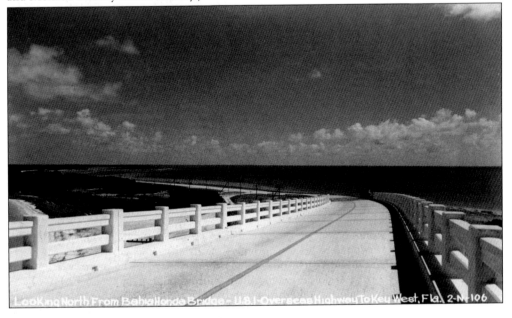

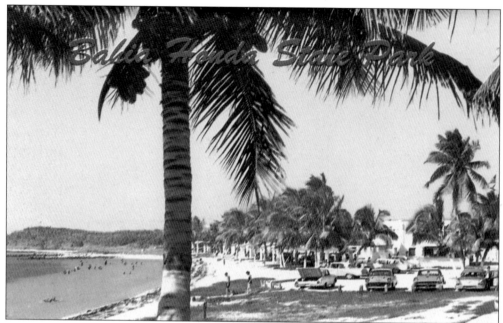

While the Florida Keys aren't generally celebrated for their beaches, the soft, sandy ones found at the 524-acre Bahia Honda State Park are the obvious exception. In fact, they are ranked among the world's best. But they aren't the area's only attraction. Located at MM 37, the park offers something for every outdoor interest. For bird-watchers, there are egrets, pelicans, roseate spoonbills, and white-crowned pigeons. (Authors' collection.)

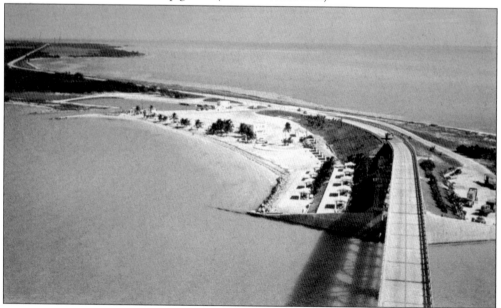

Hikers will enjoy nature trails and guided tours of magnificent beach dunes, hardwood hammocks, and forests of gnarled mangroves. Lovers of unusual plant specimens will find the small-flowered lily-thorn, plus yellow satinwood and gumbo limbo trees, as well as one of the largest remaining stands of threatened silver palms in the nation. Bahia Honda State Park also offers opportunities for fishing, boating, waterfront camping, snorkeling, and sunset tours. (Authors' collection.)

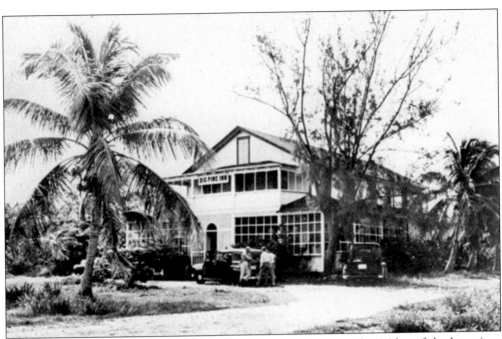

This early postcard of the Big Pine Inn provided vacationers with an idea of the luxurious accommodations that awaited them on Big Pine Key, approximately 33 miles north of Key West. Situated just across from the railroad tracks, the establishment also had a gasoline pump to meet the needs of guests arriving by automobile. (State Library and Archives of Florida.)

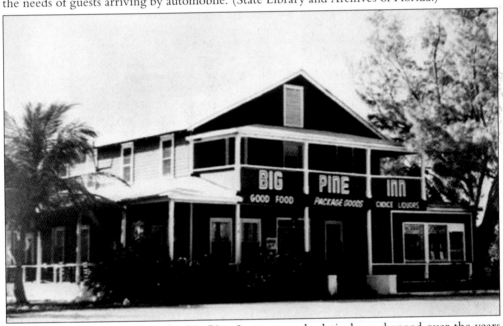

In this somewhat later view, the Big Pine Inn appeared relatively unchanged over the years except for a new paint scheme. Improved signage promised visitors "GOOD FOOD." Packaged goods and choice liquors were also available. Although a fire in 1972 destroyed the Big Pine Inn, there are several other places to stay or dine on Big Pine Key today. (State Library and Archives of Florida.)

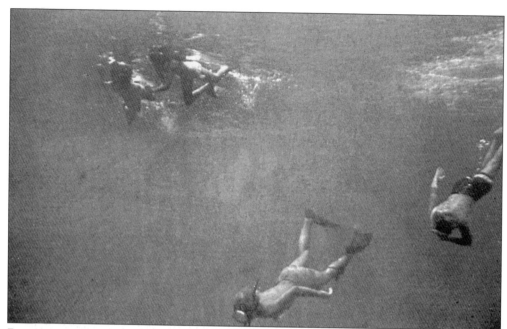

Featuring snorkelers swimming through azure waters, this Dynacolor Graphics postcard promoted the Newfound Harbor Marine Institute on Big Pine Key. According to the card, "Snorkeling in the warm, clear waters of the Lower Florida Keys can be a fantastic experience . . . and a great way to learn about the ocean." Newfound Harbor's proximity to the Looe Key National Marine Sanctuary made that an easy promise to fulfill. (Authors' collection.)

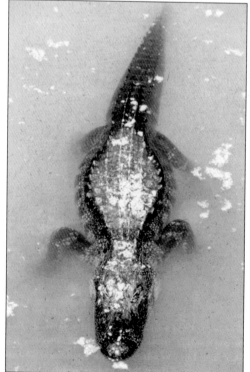

Not all of the residents of Big Pine Key are human. Dale McDonald preserved this "up-close and personal" view of an alligator sunning itself in shallow water at Big Pine Key. Savvy locals are quick to caution visitors to never venture closer than 15 feet from an alligator. Normally rather docile creatures, alligators are unpredictable and can be quite ferocious if provoked, especially during nesting season. Once hunted almost to extinction, alligators are still considered to be a threatened species. (State Library and Archives of Florida/Dale M. McDonald Collection.)

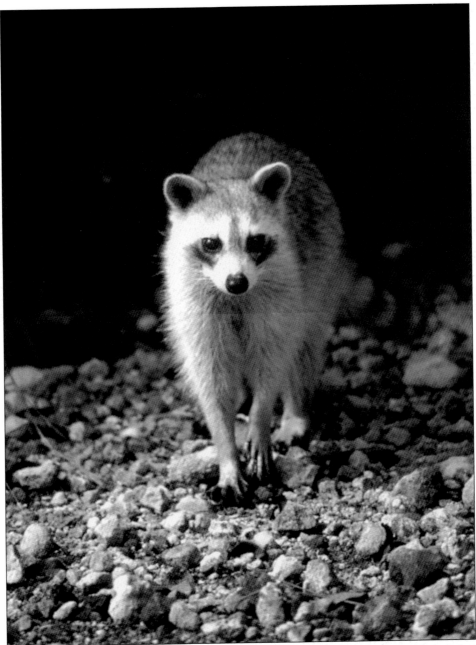

Captured in mid-stride by the camera of Dale McDonald, this raccoon appears to be out for his nightly stroll along the shoreline of Big Pine Key. On the other hand, he might be on his way to forage in the shallow waters of the mangrove roots for small fish, crabs, or other delicacies for his dinner. More detrimental to endangered marine populations, a hungry raccoon might make a quick meal of incubating sea turtle eggs buried in the warm sands of the Keys' beaches. Baby alligators still in the nest might also become victims of a hungry raccoon, despite the danger that an angry parent alligator might reverse the process. An equal if not more likely possibility is that the unsecured food supplies of vacationing campers will provide a culinary repast for this "masked bandit." (State Library and Archives of Florida/Dale M. McDonald Collection.)

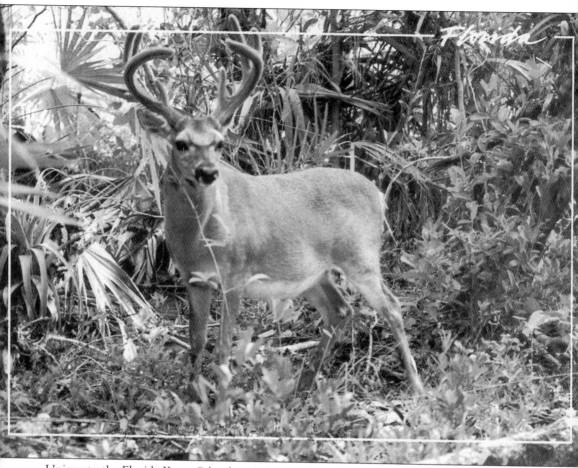

Unique to the Florida Keys, *Odocoilues virginianus clavium* is commonly known as the Key deer. The smallest of 28 subspecies of Virginia white-tailed deer, the Key deer usually weighs less than 70 pounds and stands no more than three feet tall. The majority of the tiny deer are found on Big Pine Key; some live on No Name Key and a few may occasionally be seen on other islands. Once killed as a source of food, only approximately 50 Key deer existed in the 1940s. Although still listed as an endangered species, the Key deer population is now estimated at around 800 animals, thanks to wildlife management efforts. Speed limits have also been lowered on Big Pine Key in an effort to reduce the number of Key deer killed by automobiles. (Authors' collection.)

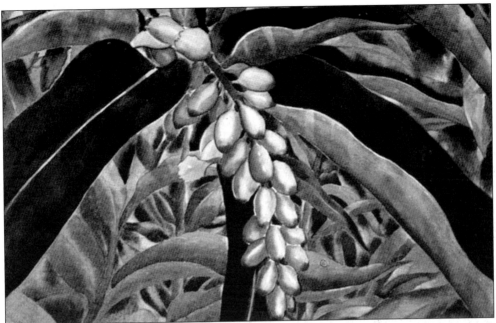

Both of these postcards offer examples of the flora for which Florida is famous. Stanley Wood, one of America's most prolific Works Progress Administration artists during the Great Depression, painted this watercolor of a ginger plant. With its lavender and fuchsia flowers surrounded by dense green leaves, the beautiful ginger plant offered a perfect Florida Keys subject. Requiring a near-tropical climate, the magnificent Royal Poinciana tree grows in only a few parts of the nation. Fortunately for residents and visitors alike, the Florida Keys is one of those places. Considered to be one of the world's most beautiful flowering trees, the Royal Poinciana can reach a height of 40 feet. In bloom from May to July, the orange-red blossoms of the aptly nicknamed "Flame Tree" also provide much-needed shade from the hot Florida sun. (State Library and Archives of Florida and Authors' collection.)

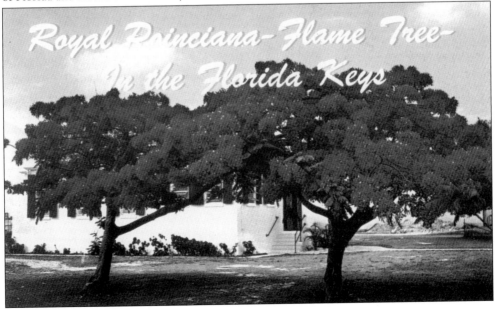

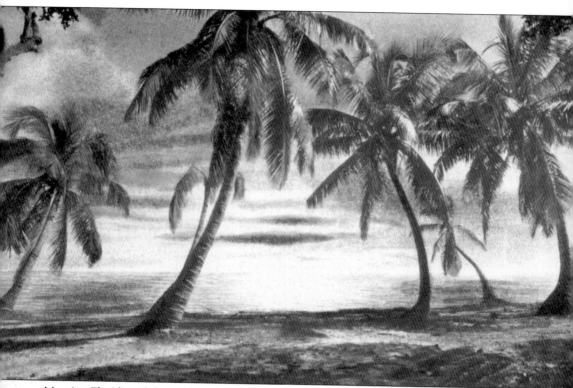

Mention Florida and the image that comes to mind is one of gently swaying palm trees. Obviously the publishers of this postcard concurred when they depicted this view of a glorious Keys sunset viewed from a palm-lined shore. Legislators agreed when they named the cabbage palm as the state tree, despite the fact that palms are not trees at all but instead considered by botanists to be tall, woody grasses. (Authors' collection.)

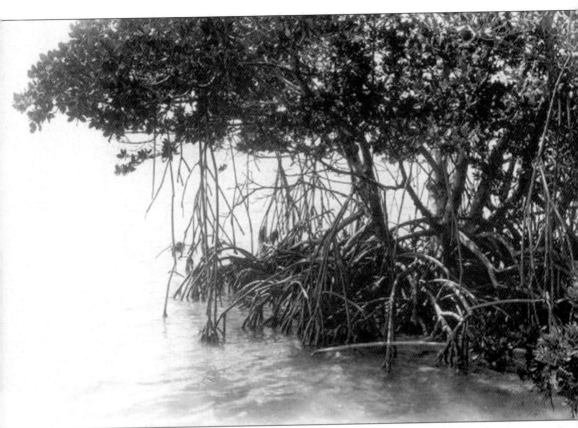

Less familiar to visitors than palm trees, mangroves are vitally important to Florida's environment. With the specialized roots pictured in this image, they help to prevent shoreline erosion. In addition to offering protected nurseries for fish, crustaceans, and shellfish, mangrove ecosystems provide food for a variety of marine species. Coastal birds use mangroves as rookeries, or nesting areas, while other animals find shelter in their roots and branches. (State Library and Archives of Florida.)

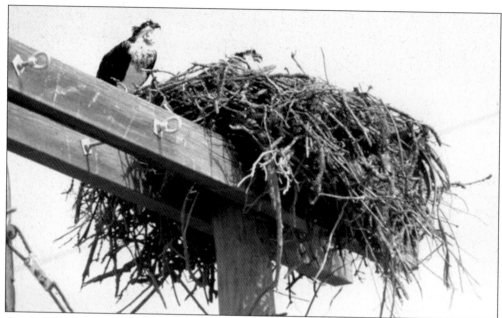

On Little Torch Key, it is not uncommon to see a magnificent osprey nesting high above the ground in a tall tree or atop a man-made structure such as this power pole. Small and quiet, the island is a tropical paradise that offers recreational opportunities including fishing, diving, snorkeling, and boating, as well as plenty of bars and restaurants where one may enjoy a cold refreshing drink or a tasty meal. (State Library and Archives of Florida/Dale M. McDonald Collection.)

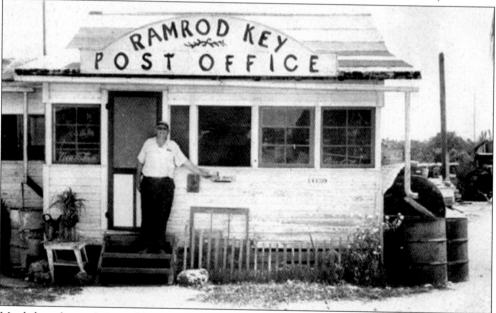

Much has changed since this postcard view of the post office at Ramrod Key was published. The laid-back atmosphere of the tiny island only 27 miles from Key West remains unaltered, however. Believed to have been named in honor of the *Ramrod*, a British ship that sank off a nearby reef in the 19th century, Ramrod Key is primarily residential today. (State Library and Archives of Florida.)

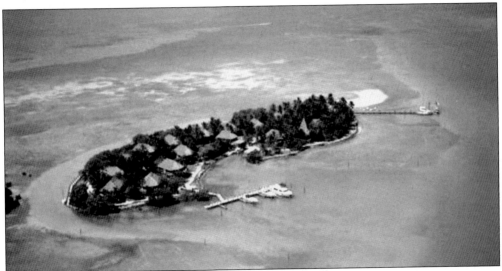

Located only a few miles from Little Torch and Summerland Keys, Little Palm Island, home to Little Palm Island Resort and Spa, is accessible only by boat or seaplane. Also known as Little Munson Island and Sheriff's Island, the 5.5-acre key has served as a private retreat for American presidents and Hollywood celebrities. *PT-109*, the movie portraying John F. Kennedy's World War II exploits, was filmed on Little Palm Island. (State Library and Archives of Florida/Dale M. McDonald Collection.)

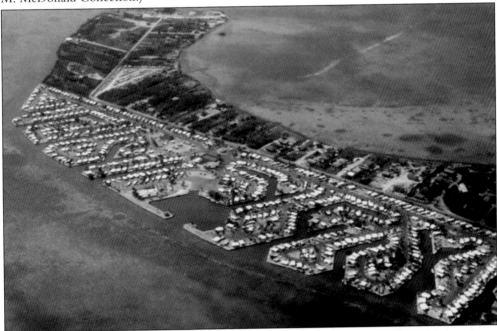

Two derivations have been suggested for the name of Cudjoe Key—the Joewood tree or a runaway slave who once resided on the island. Today Cudjoe Key is occupied by the Venture Out Resort, a 69-acre gated community and the site of numerous condominiums and mobile homes. Cudjoe Key has also been home for many years to *Fat Albert*, a blimp used to transmit anti-Castro broadcasts to Cuba, as well as other surveillance radar operations. (State Library and Archives of Florida/Dale M. McDonald Collection.)

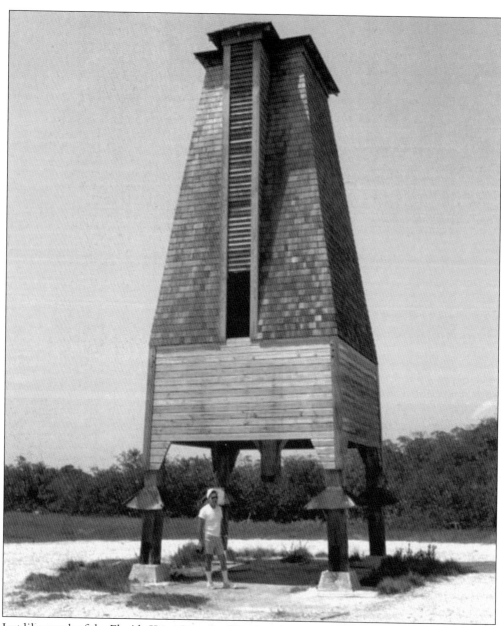

Just like much of the Florida Keys, Sugarloaf Key is quiet and relaxed. Activities include fishing, diving, snorkeling, swimming, boating, and treasure hunting. Spectacular sunrises and sunsets are abundant. Sugarloaf, however, has one tourist attraction found nowhere else in the Florida Keys—the Perky Bat Tower. Mosquitoes, the diseases they carry, and the discomfort they create have always been the bane of settlement in Florida. Sugarloaf Key developer Richter C. Perky saw bats as the answer to mosquito eradication. In 1929, Perky ordered construction of an approximately 12-foot-square, louvered wooden tower to house a colony of insect-eating bats and then waited for results that never came. While local wags argued that the mosquitoes probably ate the bats, in all likelihood, the bats just flew away. Nonetheless, in 1982, in recognition of its scientific and architectural significance, the Perky Bat Tower was added to the National Register of Historic Places. (State Library and Archives of Florida/Dale M. McDonald Collection.)

Completed in 1880, the last iron screwpile light to be constructed in the Keys still serves as an active aid to navigation. Originally illuminated by a first-order Fresnel lens, the 124-foot-tall American Shoal Lighthouse off Sugarloaf Key now uses modern optic lighting. American Shoal Lighthouse was automated in 1963, meaning that a keeper no longer had to live in the octagonal dwelling built high above the water, as shown in this early postcard. (State Library and Archives of Florida.)

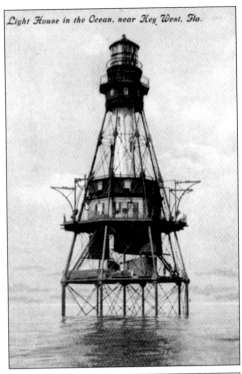

Light House in the Ocean, near Key West, Fla.

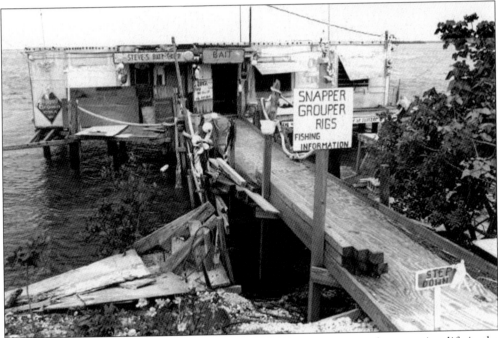

Dale McDonald, a Key West native who has devoted many years to documenting life in the Keys, recorded this image of Steve's Bait Camp on Big Coppit Key in 1982. Located off Old Boca Chica Road, the rather rustic establishment provided a place to buy bait and cold drinks, find out where the fish were biting, launch a boat, and head out in search of grouper and snapper. (State Library and Archives of Florida/Dale M. McDonald Collection.)

The Sugarloaf Lodge, located on U.S. 1 at MM 17, offered its guests a dazzling array of amenities. Only 17 miles from Key West, the lodge advertised, "Airfield, marina, charter boats, restaurant, TV-radio, phones, air conditioning, heat, efficiencies, pool." The Plastichrome card by Colourpictures Publishers of Boston, Massachusetts, made it obvious that each of the establishment's 55 rooms were located on the waterfront and presented an unobstructed view of the surrounding water. (Authors' collection.)

On this card postmarked 1963, a look at the interior showed the level of luxury experienced by guests. Large, wood-paneled rooms with wall-to-wall carpeting allowed plenty of space for entertaining or relaxing. Originally built in the early 1960s, Sugarloaf Lodge still provides that comfortable, down-home, folksy feeling reminiscent of decades past. And for a tropical touch, guests can try a glass of the lodge's famous Sugarloaf Punch at the Tiki Bar. (Authors' collection.)

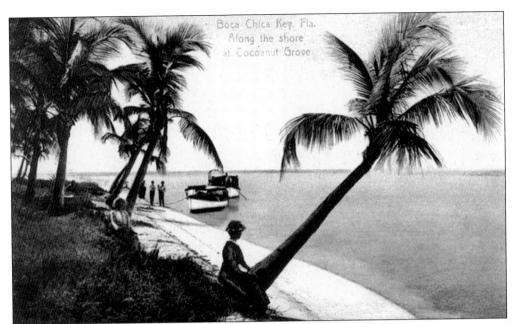

Albeit more elegantly attired than most of the visitors who spend time along the shoreline of the Keys today, these two women and their companions still appeared to be enjoying a relaxing view of the water on Boca Chica Key. Home to the Key West Naval Air Facility and hundreds of military personnel, the island today is also far busier than this postcard published by Hugh C. Leighton of Portland, Maine, would indicate. (State Library and Archives of Florida.)

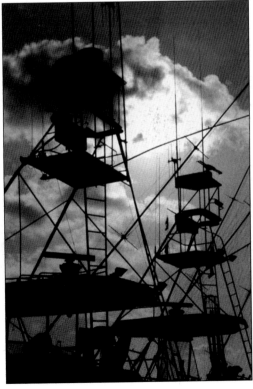

Silhouetted against a backlit sky in October 1987, these charter boats with their tuna towers (fishing platforms) presented an image guaranteed to gladden the heart of any sport fisherman. While similar sights can be found throughout the Keys, these particular boats were moored at Stock Island's Oceanside Marina. Extending from MM 6 to 4, Stock Island offers a heavily commercialized entrance into Key West. (State Library and Archives of Florida/Dale M. McDonald Collection.)

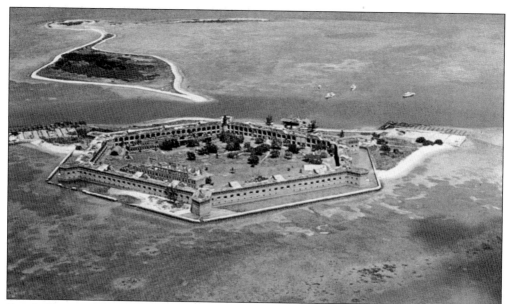

Fort Jefferson, the "Key to the Mexican Gulf," is located in the string of islands known as the Dry Tortugas. Initial construction of the fort, named in honor of Pres. Thomas Jefferson, began in 1846. Erected on the 16-acre Garden Key, approximately 68 miles west of Key West, Fort Jefferson was designed to serve as part of America's early coastal defense system. (Monroe County Public Library.)

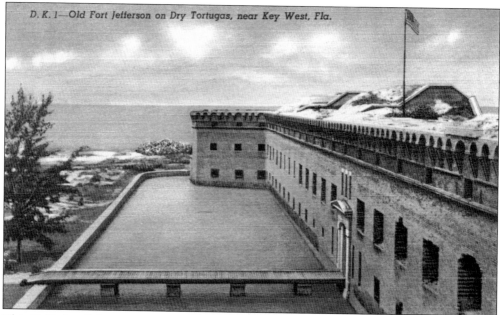

D. K. 1—Old Fort Jefferson on Dry Tortugas, near Key West, Fla.

This C. T. Art Colortone postcard published by Gulf Stream Card and Distributing Company presented an idea of Fort Jefferson's mid-19th-century style of military architecture with its brick walls rising some 45 feet above a surrounding moat. Although construction of the six-sided fort began in 1846 and continued for more than a quarter of a century, Fort Jefferson was never completed. Occupying approximately 10 acres, the fort was intended to house a military force of 1,500 men and 450 guns. (Monroe County Public Library.)

During the Civil War, the Union-occupied Fort Jefferson played an active role in the blockade of Confederate shipping. It also served as a federal prison. Dr. Samuel Mudd, convicted of conspiracy for treating the injuries of Pres. Abraham Lincoln's assassin, John Wilkes Booth, was undoubtedly the fort's most-famous prisoner. Mudd eventually received a presidential pardon. The National Park Service currently operates Fort Jefferson as a tourist attraction. (Library of Congress.)

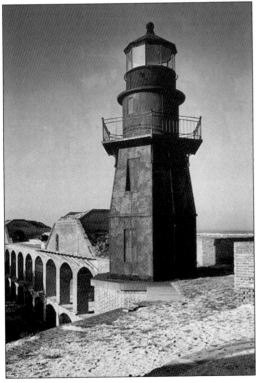

Replacing an earlier storm-weakened structure constructed in 1826, a new lighthouse, known as the Tortugas Harbor Light, was built atop the fort's walls in the mid-1870s. Covered by sheets of boilerplate iron, the unusual six-sided metal lighthouse operated until its deactivation in 1921. On January 4, 1935, Pres. Franklin D. Roosevelt proclaimed Fort Jefferson, including the lighthouse, a national monument. (Library of Congress.)

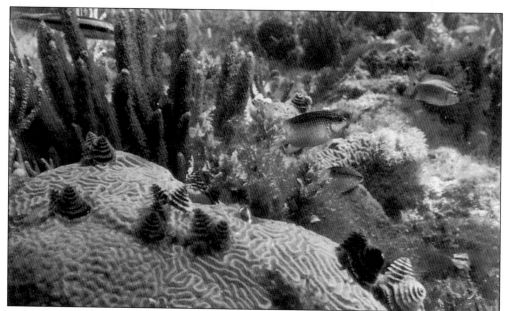

Produced by the Florida National Parks and Monuments Association, this postcard advertising Fort Jefferson National Monument featured beautiful coral reefs—something for which the Florida Keys are world famous: "Coral Reefs . . . The warm clear waters of the Dry Tortugas and maximum available light combine to produce optimum conditions for the development of coral reefs in the shallow waters of the monument. This reef complex supports a myriad of colorful marine life." (Authors' collection.)

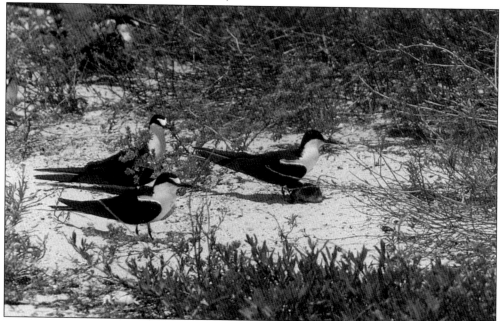

Another card by the same publisher promoted yet one more aspect of Fort Jefferson National Monument: "Tortugas Birds . . . One of our great wildlife spectacles occurs each year between April and September, when sooty terns gather for their nesting season on Bush Key. Terns come by the thousands from the Caribbean Sea and west central Atlantic Ocean." (Authors' collection.)

80

The 157-foot-tall lighthouse on Loggerhead Key in the Dry Tortugas was first lighted in 1858. Constructed of brick, the lighthouse's lower half was painted white, the upper portion black. Assisted by his wife and two young daughters, Benjamin Kerr served as the first lighthouse keeper. Despite efforts to decommission the Loggerhead Key Lighthouse, it still entered the 21st century in active operation as an aid to navigation. (State Library and Archives of Florida.)

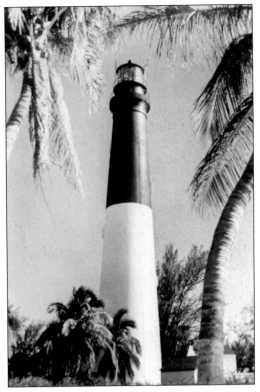

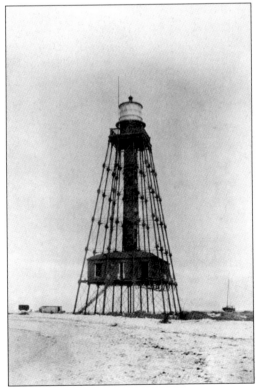

Being a lighthouse keeper was often a dangerous occupation. Constructed of brick on a small, frequently submerged island, the first Sand Key Lighthouse collapsed in a hurricane in 1846, killing keeper Rebecca Flaherty and her children. Erected in 1853, the iron screwpile replacement shown in this postcard was located nine miles south-southwest of Key West and is still in active operation under the auspices of the U.S. Coast Guard. (State Library and Archives of Florida.)

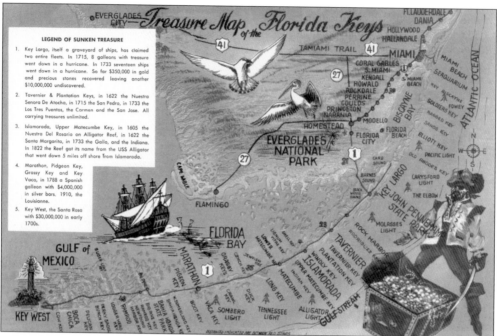

Treasure Map of the Florida Keys

LEGEND OF SUNKEN TREASURE

1. Key Largo, itself a graveyard of ships, has claimed two entire fleets. In 1715, 8 galleons with treasure went down in a hurricane. In 1733 seventeen ships went down in a hurricane. So far $350,000 in gold and precious stones recovered leaving another $10,000,000 undiscovered.

2. Tavernier & Plantation Keys, in 1622 the Nuestra Senora De Atocha, in 1715 the San Pedro, in 1733 the Los Tres Puentos, the Carmen and the San Jose. All carrying treasures unlimited.

3. Islamorada, Upper Matecumbe Key, in 1605 the Nuestra Del Rosario on Alligator Reef, in 1622 the Santa Margarita, in 1733 the Gallo, and the Indiana. In 1822 the Reef got its name from the USS Alligator that went down 5 miles off shore from Islamorada.

4. Marathon, Pidgeon Key, Grassy Key and Key Vaca, in 1788 a Spanish galleon with $4,000,000 in silver bars. 1910, the Louisianne.

5. Key West, the Santa Rosa with $30,000,000 in early 1700s.

No treasure map was needed. This Original Color Photo postcard revealed the secret location of many sunken ships off the Florida Keys. According to the card, "The Spanish Empire has lost an estimated $100,000,000 in treasures. After a storm or a hurricane, gold and silver coins will wash up on one of the sandy beaches in the Keys, to the delight of some tourist or native." It sounds so easy, doesn't it? (Authors' collection.)

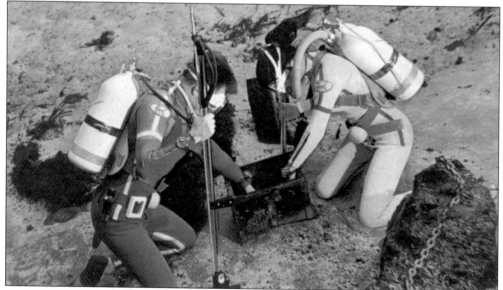

As evidenced by this postcard, few places in the world can offer better diving or snorkeling than the Florida Keys. Hundreds of sunken ships complete with rusted anchors and cannons may conceal Spanish gold or pirate treasure. There are also magnificent living coral reefs, with names such as Hens and Chickens Reef, Horseshoe Reef, and Pickles Reef, teeming with colorful fish guaranteed to excite anyone and everyone. (Authors' collection.)

82

Five

SOUTHERNMOST

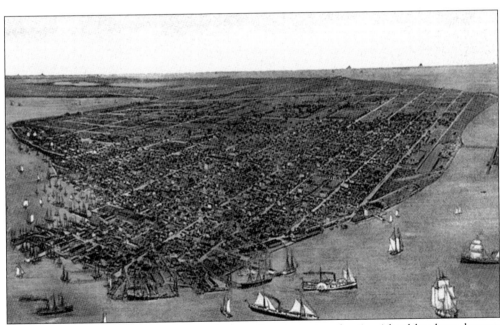

Finally, at long last—Key West! Over the past few centuries, the tiny island has been known by many names—Los Martires, Cayo Hueso, Bone Key, Rainbow's End, the Last Resort, Margaritaville, and the Southernmost City. Regardless of what it was called, however, the tiny island has always been a busy place, as evidenced by this Curt Teich Company postcard titled "Bird's Eye View of Key West." (State Library and Archives of Florida.)

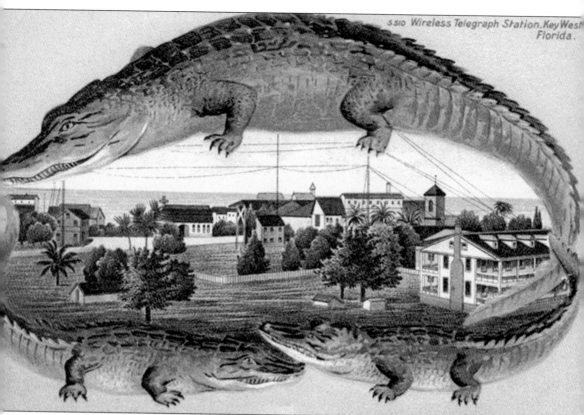

Only two miles by four miles in land area and closer to Cuba than the U.S. mainland, Key West has been a thriving port, a bastion of military strength, the southernmost terminus of the Florida East Coast Railway, and the end of a major American highway. Soldiers and sailors, fishermen and farmers, salvagers and settlers, cigar makers and spongers, hoteliers and restaurateurs, shopkeepers and entertainers—all have made their homes on the tiny island. And then there are the thousands and thousands of visitors that come to Key West each year to revel in its unique ambiance. Published by S. Langsdorf and Company of New York, this early view of the Key West telegraph station offered a glimpse of that funky, fanciful flavor. (State Library and Archives of Florida.)

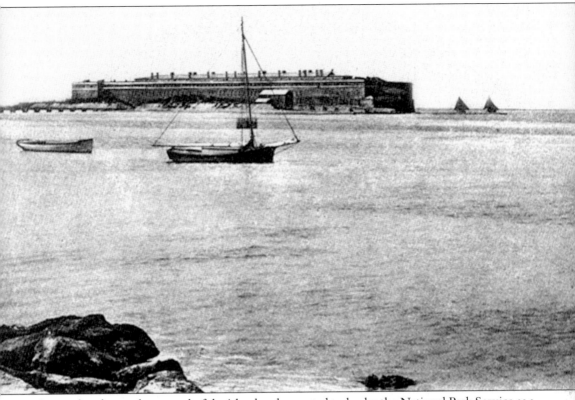

Located at the southwest end of the island and operated today by the National Park Service as a national historic site, Fort Zachary Taylor was built between 1845 and 1866 as part of Florida's coastal defense system. Its occupation in 1861 by troops under the command of Capt. James Brannan ensured that Key West remained in Union control during the Civil War. Published in Germany, this postcard offered an early view of the fort. (State Library and Archives of Florida.)

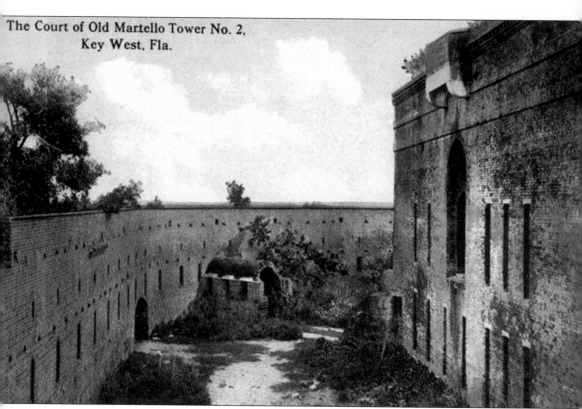

The Court of Old Martello Tower No. 2.
Key West, Fla.

Union forces began construction of two brick fortifications in 1858 to protect the coast east of Fort Taylor. When advances in weaponry made the masonry walls of the East and West Martello towers obsolete, construction ended. Currently listed on the National Register of Historic Places, both buildings have been adapted for peaceful purposes. (State Library and Archives of Florida.)

Postmarked in 1935, this postcard is titled "The Southernmost U.S. Weather Bureau in Continental United States." Published by E. C. Kropp of Milwaukee, Wisconsin, the card pictured the masonry building constructed in 1911 by the Weather Service. With its southernmost location, the station was in the best possible site to forecast impending tropical storms. In recent years, the building was converted into a bed-and-breakfast inn. (Authors' collection.)

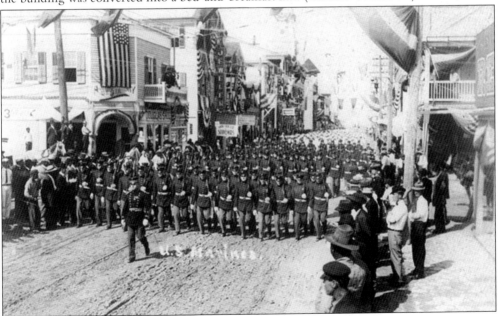

Key West has had a strong military presence ever since the day in 1821 when Lt. Matthew C. Perry arrived in Key West aboard the U.S. Navy vessel *Shark* and claimed the island for the United States. According to information on the real-photo postcard, this parade of U.S. Marines took place in Key West on January 22, 1912. Within just a few years, many of the young men pictured may have been fighting overseas during World War I. (State Library and Archives of Florida.)

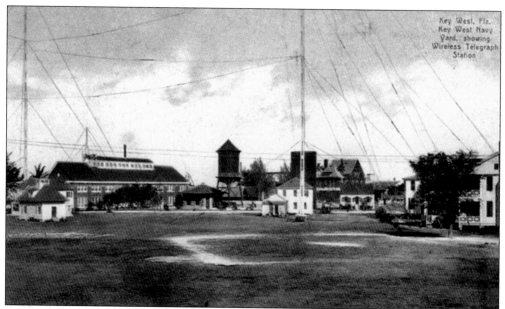

Published by Hugh C. Leighton of Portland, Maine, this early postcard pictured the Key West Navy Yard, along with its wireless station and barracks. One can almost imagine squadrons of men drilling in formation on the grassy parade ground. From an installation initially staffed by just a few hundred men, the naval presence in the Southernmost City would grow by leaps and bounds. (Key West Art and Historical Society.)

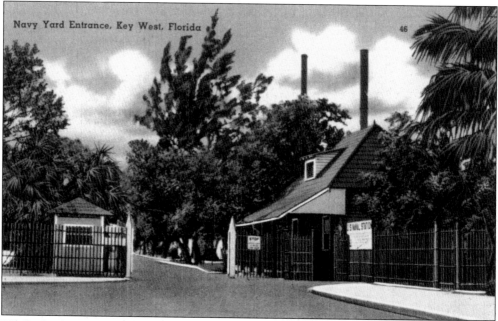

While this linen Tichnor Quality Views postcard featured the entrance gates to the U.S. Naval Station, its caption discussed the beauties of nature. "In the Navy Yard is a wealth of notable trees, the rare Geiger tree, prodigal with scarlet blossoms and discovered to the botanical world by the sketch Audubon made of it as a background for a painting of the white-crowned pigeon; the 'Sausage Tree' and many others." (Authors' collection.)

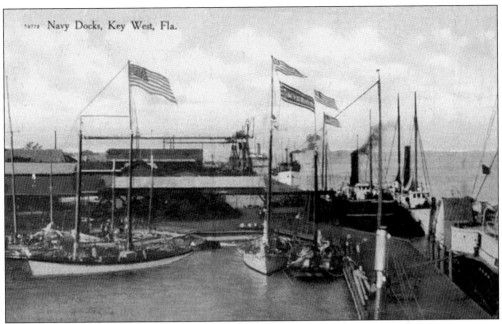

Navy Docks, Key West, Fla.

When Capt. David Porter of the U.S. Navy arrived in Key West in April 1823, his orders were to protect American citizens from pirates, suppress the slave trade, and establish a naval base at Key West. For that purpose, he was given a fleet consisting of eight shallow-draft schooners, five 20-oared barges, and the USS *Seagull*, a steam-powered warship. These two postcards show the growth of the navy yard in later eras. Dating from the early 1900s, the upper card pictured a variety of sail- and steam-powered vessels, all flying the American flag. The bottom card offered a more modern view of the Key West Naval Station. During World War II alone, more than 14,000 ships logged into Key West. From its inception, the base was vital to American security. (State Library and Archives of Florida and Authors' collection.)

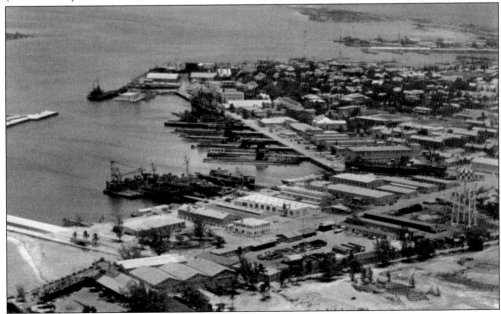

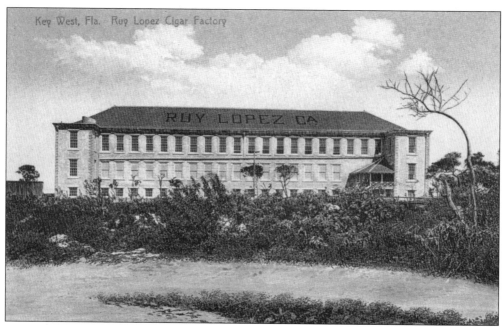

William Wall founded Key West's cigar-making industry in 1831. The first large-scale manufacturing began in 1867 with Samuel Seidenberg's factory when a Cuban revolution provided an influx of expert workers. The growing industry reached its peak in the 1890s, despite a disastrous fire in 1886 that destroyed the wooden factories. Many, including the Ruy Lopez cigar factory pictured in 1905 in the top card, were rebuilt of brick. But Mother Nature wasn't finished yet. Even masonry structures couldn't withstand the forces generated by a devastating hurricane in 1909. The bottom postcard, showing the Havana American factory after the storm, proved the extent of the damage. (Monroe County Public Library.)

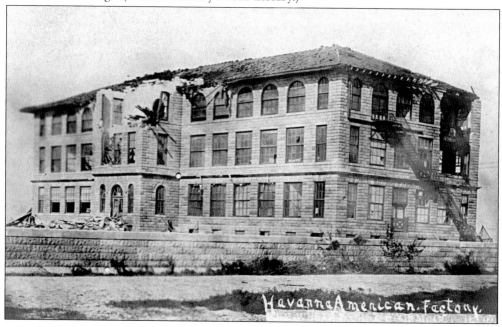

Havana American Factory

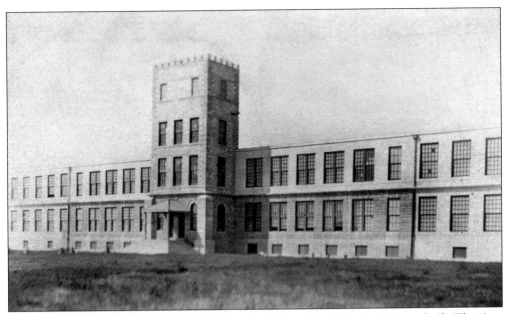

By 1910, many of the cigar factories, including the Havana American, had been rebuilt. The cigar industry in Key West was dying, however. At the industry's peak in 1890, thousands of workers produced over 100 million cigars annually. Fires, hurricanes, labor conflicts, the relocation of factories and workers to Tampa, and the popularity of cigarettes eventually caused Key West's decline as the Cigar City. (Monroe County Public Library.)

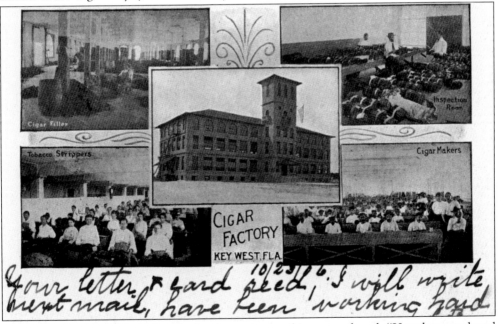

Dated October 23, 1916, the handwritten notation on this postcard read, "Your letter and card received, I will write next mail, have been working hard." If the writer was employed at the cigar factory pictured, that was certainly true, since the work was painstaking and the hours long. The job probably wouldn't last much longer, however. By the 1930s, many of the factories had been abandoned. (Monroe County Public Library.)

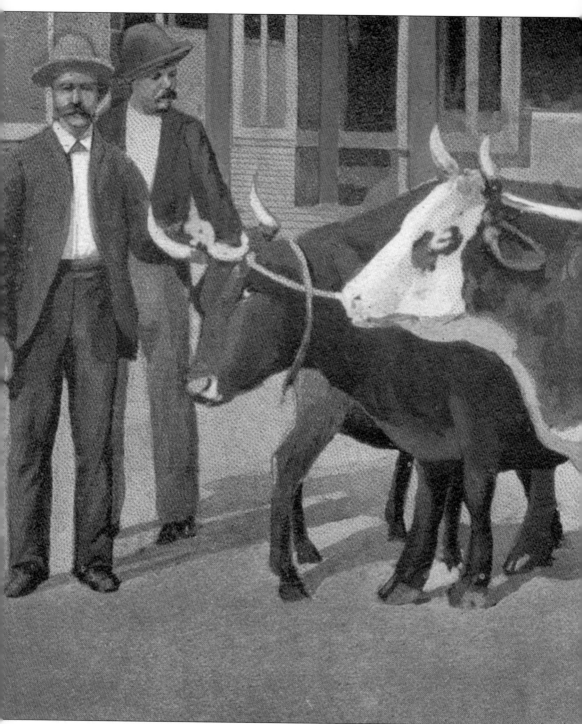

Regardless of how people earned a living, they still needed to eat. By the early 1900s, most people had recognized the importance of fresh milk and dairy products in a healthy diet. Predating giant supermarkets, this image epitomized the idea of "custom delivered fresh to your door." Published by Frank Johnson of Key West, this C. T. American Art postcard was titled "Dairy

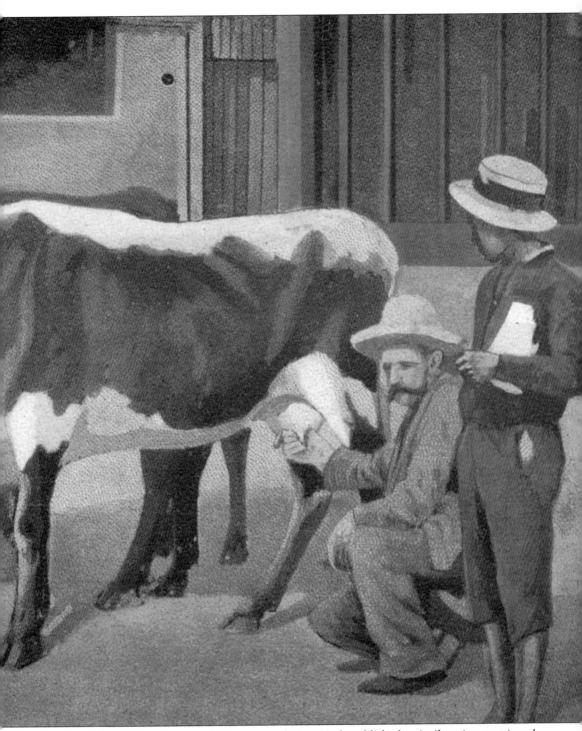

on Foot." A. C. Bosselman and Company of New York published a similar view captioned "Walking Dairy." Obviously the subject matter was believed to have a certain whimsical appeal to postcard purchasers. (Monroe County Public Library.)

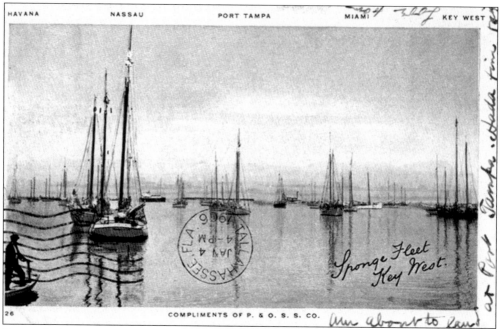

Sponge Fleet Key West.

Am about to land at Port Tampa, attack time

26 COMPLIMENTS OF P. & O. S. S. CO.

Postmarked January 4, 1904, this postcard was given to customers of the Peninsular and Occidental Steamship Company. Surrounding the image of the sponge fleet in the harbor at Key West were the names of the company's various ports of call—Havana, Nassau, Port Tampa, Miami, and Key West. Someone named Tom wrote along the border, "Am about to land at Port Tampa. Had a fine trip." (State Library and Archives of Florida.)

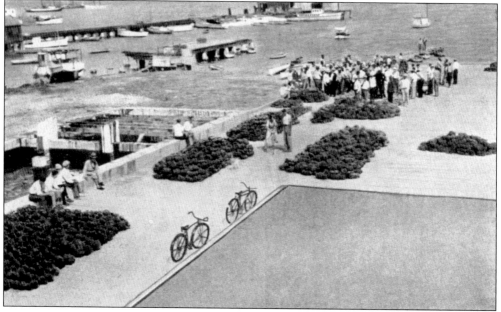

The fleet sold its catch of sponges in open-air markets located on the docks in Key West. From its beginning in the late 1840s, Key West's sponge industry grew at a phenomenal pace. By 1890, the sponge fishing fleet numbered 350 boats. In what had become the sponge capital of the world, nearly 1,300 men were harvesting 165 tons of sponges each year. (Authors' collection.)

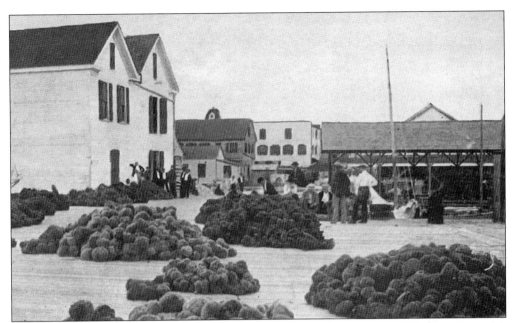

From a fleet of small boats attached to a mother ship, Key Westers harvested sponges with pronged poles that reached the seabed 30–40 feet below. In Tarpon Springs, Florida, spongers wearing helmeted diving suits gathered the sponges by hand and carried them to the surface—a quicker, less expensive procedure. In both instances, the ships then returned to port where the sponges were spread out to dry. (Monroe County Public Library.)

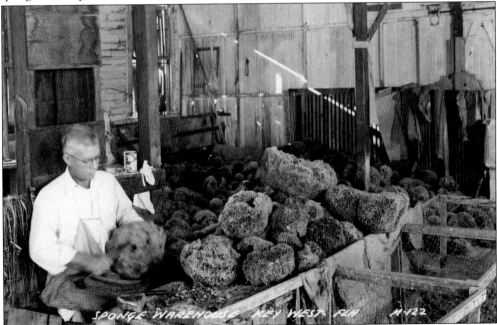

Like the cigar industry, the sponge trade was very labor intensive. After being plucked from the ocean bottom, brought to shore, and dried, the sponges had to be sorted, carefully trimmed by hand, and then sold at auction. Demand was so great that by the early 1900s, the supply in the clear waters of the Florida Keys began to diminish. (Monroe County Public Library.)

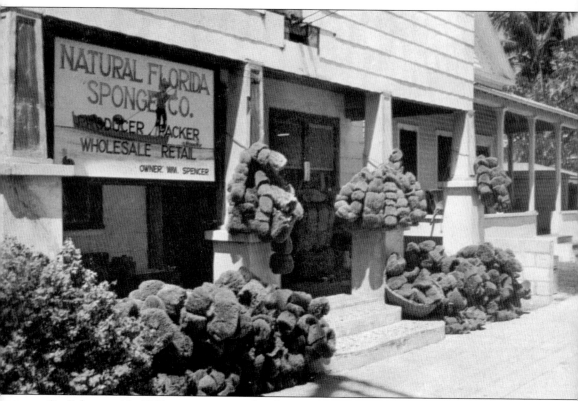

On February 15, 1957, someone named Helen mailed this postcard that pictured a Key West sponge shop to a friend in Bloomsburg, Pennsylvania. By that year, however, many of those sponges probably hadn't been harvested in the Florida Keys. From a booming business at the end of the 19th century, the local industry had virtually disappeared by the late 1930s. A fungus had devastated the sponge beds, synthetic sponges had been developed, and much of the trade had moved north to Tarpon Springs. (Authors' collection.)

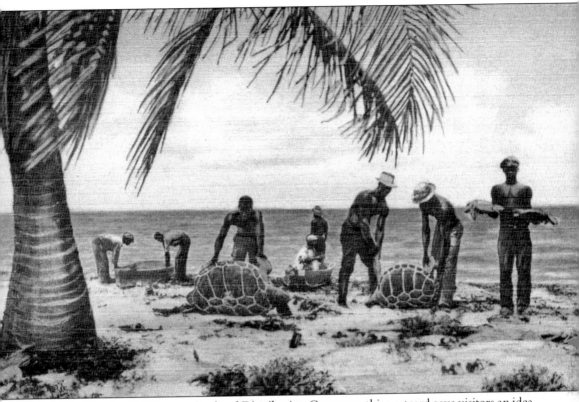

Published by the Gulf Stream Card and Distributing Company, this postcard gave visitors an idea of the process behind a popular entree served in local restaurants. According to the back of the card, "The Green Turtle (Chelonia mybes) living in the warm water surrounding the Florida Keys is widely renowned as an article of food and no trip to Florida is complete without eating a delicious green turtle steak." (Monroe County Public Library.)

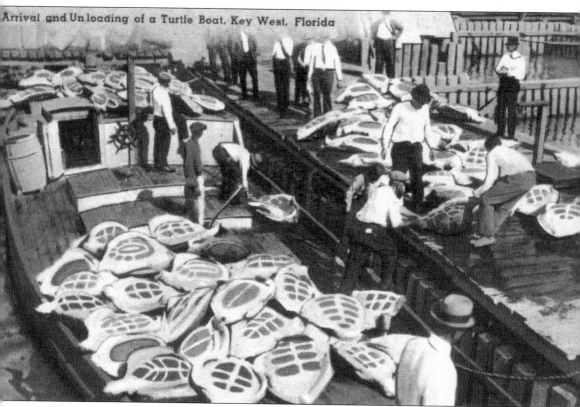

Arrival and Unloading of a Turtle Boat, Key West, Florida

Loggerhead, hawksbill, and trunk-back turtles, weighing from 50 to 500 pounds, were also captured in the waters between Florida and Central America and brought by boat to Key West. This postcard, one of 18 images contained in a postcard viewbook by Tichnor Brothers of Boston, featured the arrival and unloading of one of those boats. (Authors' collection.)

Once in Key West, the live turtles were confined temporarily in water-filled pens called kraals or crawls, a name taken from the Dutch word for corrals. This real-photo postcard, taken looking west toward Christmas Island, pictured the turtle kraals as well as the Thompson piers and boat ways. (Monroe County Public Library.)

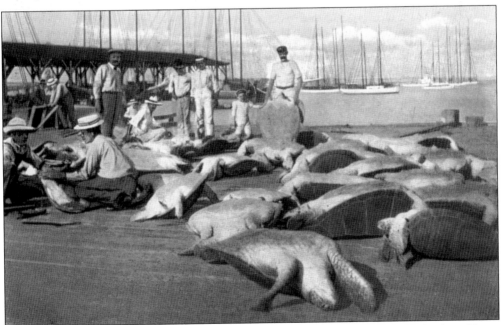

Of the thousands of turtles brought to Key West, certain varieties were considered to be culinary delicacies, while others were valuable for products made from their shells. To speed the process, a cannery where workers butchered and processed the creatures into turtle soup or canned meat was located adjacent to the turtle kraals. (Authors' collection.)

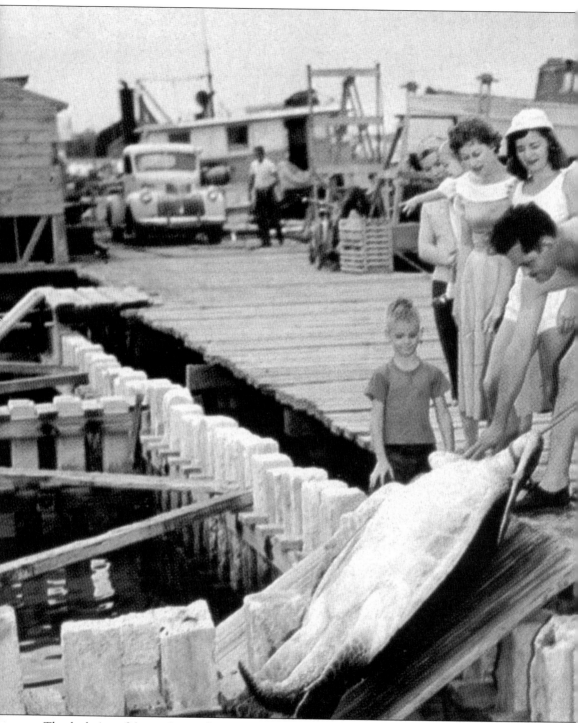

The depletion of the turtle population brought an end to the industry in the 1970s. Although still threatened by many other factors, thanks to the efforts of conservation agencies, coupled with the enactment of stronger environmental laws designed to protect the species, endangered turtles can once again be found in the waters of the Florida Keys. As this postcard attests, however, many

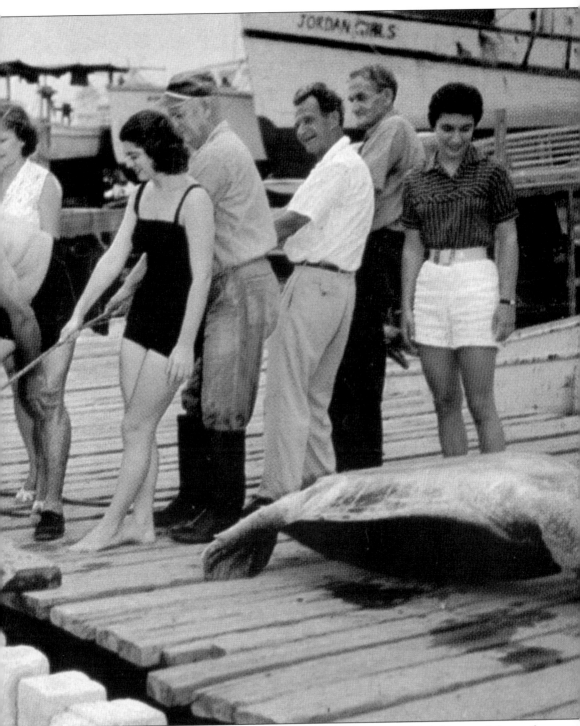

tourists during the 1950s found an up-close glimpse of the captured inhabitants of the turtle kraals an entertaining part of their vacation experience. Today visitors can see the endangered turtles swimming in their natural environment or in secure surroundings such as aquariums rather than on their way to becoming someone's dinner. (Authors' collection.)

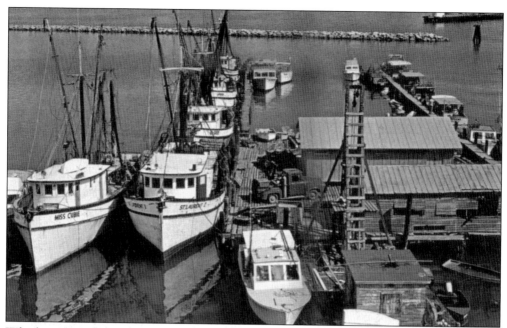

Whether a backdrop for a Hemingway novel, a source of food, or a means of earning a living, the sea has always been a part of life in Key West. Early fishermen supplemented their incomes salvaging cargo from ships run aground on shoals surrounding the Keys. The fish they caught fed not only residents; with the advent of refrigeration, seafood enthusiasts across the country enjoyed their catch. (Authors' collection.)

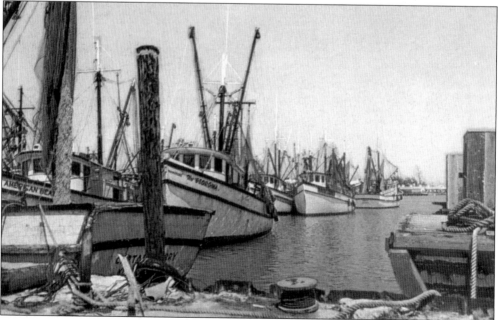

In 1949, local incomes received a boost with the discovery of "pink gold," an apt name for the vast quantities of large shrimp found near the Dry Tortugas. By the late 1960s, the shrimp industry had become a major factor in Key West's economy, filling the waterfront with docks, ice houses, processing plants, and hundreds of shrimp boats. (Authors' collection.)

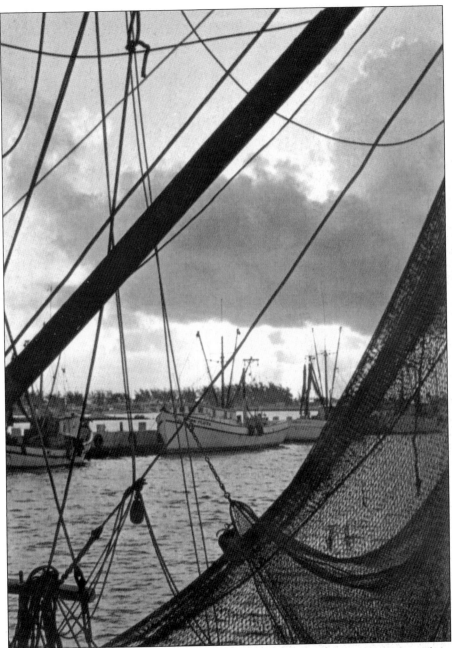

The Florida State News Bureau proudly offered this postcard view of the harbor with its net-draped commercial fishing boats romantically silhouetted against a sunset. All was not rosy, however. Crews encountered stepped-up Coast Guard drug enforcement efforts that included frequent searches for "square grouper" (bales of marijuana). Environmental concerns and stricter regulations further altered the fishing industry. By the early 1990s, declining catches combined with increased foreign competition to weaken the shrimp market, although today's discerning shoppers still prefer pink Key West shrimp to cheaper imports. Crews continue to fish the surrounding waters for a living, but boats also take visitors sport fishing, diving, snorkeling, and sightseeing. (Authors' collection.)

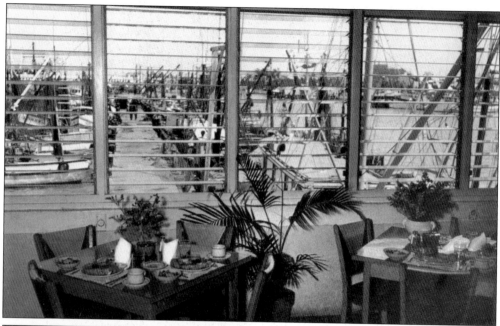

It wasn't until Key West experienced the devastating effects of the Great Depression that a concentrated effort was made to attract visitors to the Florida Keys. By the end of the winter of 1934–1935, thousands of people had visited Key West for the first time. The city had a new industry—tourism. These two cards pictured the dockside view from within the A & B Lobster House, as well as the interior of the restaurant. On February 21, 1967, the Kemps wrote the following message to folks back home in Illinois: "We had good roads and fine weather has been with us. We had the table marked x Sat. eve. We are all going to the beach for breakfast in the morning. All seven of us went to church this a.m. The fruit trees are loaded. The temp has been 70 at nite, 80 in the daytime." Just one of a multitude of dining spots in Key West today, the restaurant continues to be popular with residents and visitors alike. (Authors' collection.)

Culinary treats abound in Key West. Local restaurants serve hundreds of delicious dishes. No one needs to go hungry—there is something to suit every palate. Every ethnicity is represented as diners can choose from Italian, French, Japanese, and other cuisine. Try a Cuban sandwich, black beans and rice, or fried plantains today, perhaps crab cakes, jerk chicken, or another Caribbean specialty tomorrow. Fresh fish is always a good choice. Peel a pound of luscious pink Key West shrimp, seasoned to perfection. What could be more popular than a just-caught Florida lobster? Start the meal with an order of conch fritters or a bowl of steaming chowder. And be sure to save room for a slice of key lime pie to round out an epicurean feast. (Authors' collection.)

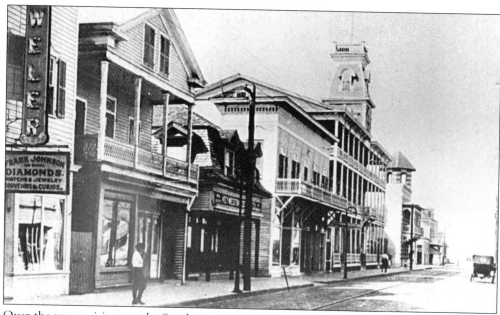

Over the years, visitors to the Southernmost City have had a variety of places to stay. Back in the days of horse-drawn carriages and electric trolley cars, the Jefferson Hotel was one choice, as this postcard published by the Key West News Company showed. With its open balconies overlooking Duval Street, the hotel offered guests a ringside view of activity on the street below. (State Library and Archives of Florida.)

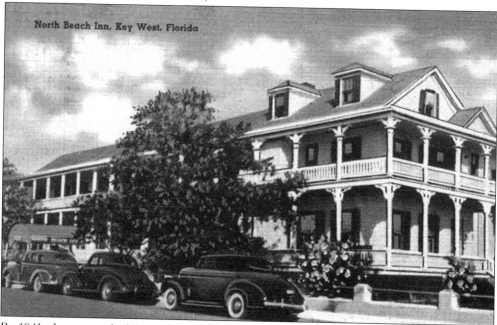

By 1941, the postmarked date on this Tichnor Brothers postcard, the North Beach Inn offered another housing alternative. Careful examination of the architectural details of the structure indicates that additional rooms had been grafted onto the left-hand side of what probably began as a private residence. Note the dormer windows and decorative gingerbread trim on the original building. (State Library and Archives of Florida.)

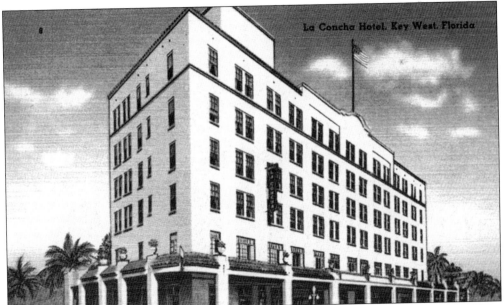

Located on the corner of Duval and Fleming Street, the seven-story La Concha Hotel epitomized the latest in hotel style when it opened in January 1926. Since then, it has been home to guests both famous and less well known. For example, in 1946, while staying on the sixth floor prior to purchasing a Key West residence, author Tennessee Williams wrote *Summer and Smoke*. (State Library and Archives of Florida.)

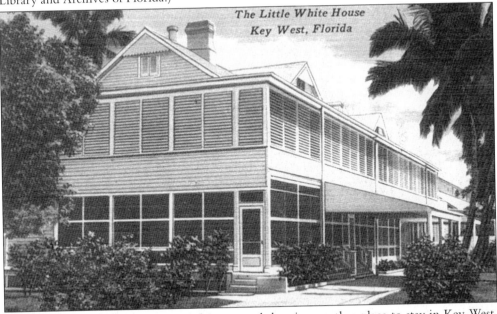

The Little White House
Key West, Florida

L. A. Valladares and Son published this postcard showing another place to stay in Key West. This one was open to only a few select guests, however. Originally built as the home of the Key West Naval Station's commander, the residence was christened "Truman's Little White House" by the press after Pres. Harry Truman stayed there for 175 days during his presidency. Other guests have included presidents Eisenhower, Kennedy, and Carter. (State Library and Archives of Florida.)

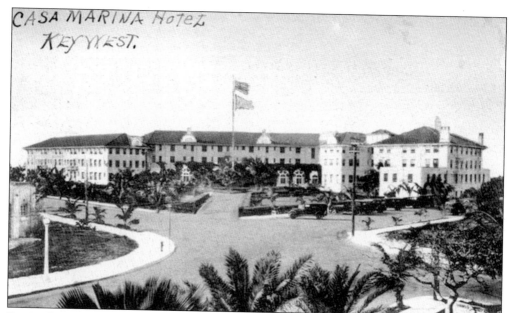

For Hollywood movie stars or wealthy socialites such as the Astors and the Vanderbilts, Casa Marina offered all of the amenities. Built by the Florida East Coast Hotel Company, a subsidiary of Flagler's railroad, the luxurious 200-room resort hotel opened on New Year's Eve 1921. Advertised as the "most up-to-date in the South," Casa Marina's public areas exemplified pre-Depression elegance and sophistication. (State Library and Archives of Florida.)

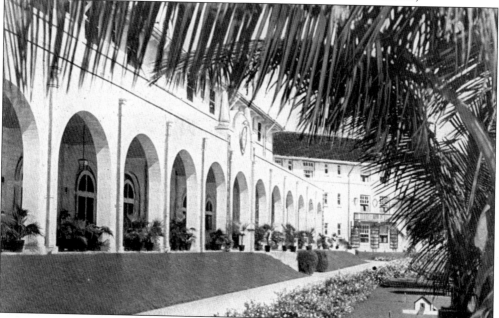

Tropical plants decorated the arched piazzas of the 152-foot-long main building, while wicker chairs offered guests a place to relax. Although the hotel cost more than $350,000 originally, such luxury wasn't immune to the effects of the Great Depression. After years of hard times, Casa Marina has been beautifully restored and lives on under the auspices of a major hotel chain. (Authors' collection.)

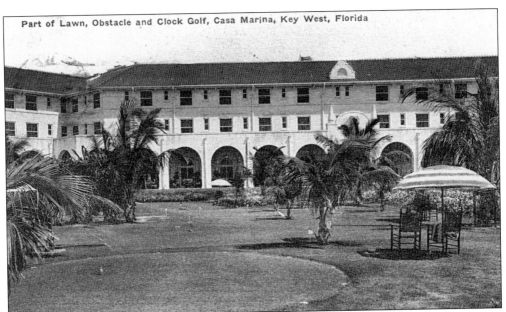

Part of Lawn, Obstacle and Clock Golf, Casa Marina, Key West, Florida

Published by the Albertype Company of New York and mailed from Key West on February 25, 1931, this hand-colored postcard offered a glimpse of a leisure activity at Casa Marina—lawn, obstacle, and clock golf. The caption on the back of the card read, "For those who desire the last word in beauty, comfort, and service, the Casa Marina Hotel, a unit in the Florida East Coast system, situated on the most southerly beach in the United States, offers all that luxury lovers can desire." (Monroe County Public Library.)

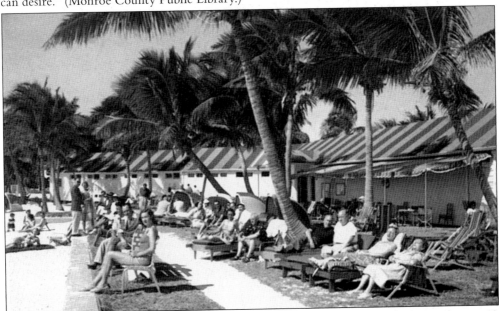

Casa Marina provided a number of other recreational pursuits including fishing, sailing, golf, croquet, and trap shooting. Guests could also play tennis on the hotel's private courts. Since Casa Marina offered not only its own 500-foot-long private stretch of sand, but also a selection of deck and lounge chairs at its Beach Club, sunbathers had their choice of locations for soaking up a few rays. (State Library and Archives of Florida.)

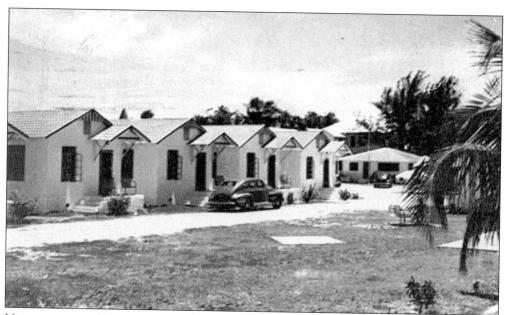

Not everyone could afford the upscale accommodations provided by the Casa Marina. For those vacationers with less money in their wallets or tastes that tended to be more informal, places like the Ocean View Hotel, Cottages, and Apartments offered an alternative. Published by Dexter Press of Pearl River, New York, this postcard was postmarked May 9, 1950. (State Library and Archives of Florida.)

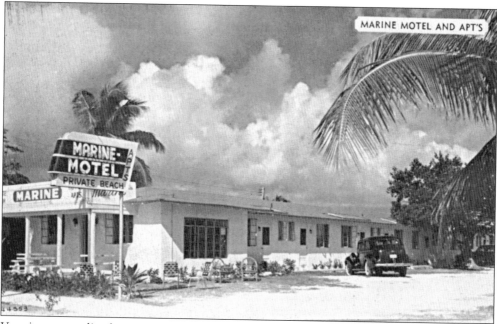

Vacationers traveling by automobile spawned a new type of lodging—motels. The Marine Motel and Apartments at South and Simonton Streets advertised, "Rooms, Suites, Housekeeping Apts. All Private Baths. On the Ocean, Private Beach, Swimming Pool. Motel Luxury at Moderate Rates. Call 1478." According to this Silvercraft postcard made by Dexter Press, Jack Tallon served as the establishment's manager. (Authors' collection.)

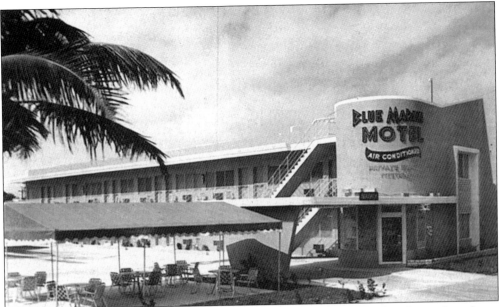

The Blue Marlin Motel went one step further in its advertising. Displayed prominently on the front of the building were those magical words so important in a tropical climate: "AIR CONDITIONING." Still in operation today at 1320 Simonton Street, the Blue Marlin looks much the same as it did when Valence Color Publishers of Miami created this postcard. (State Library and Archives of Florida.)

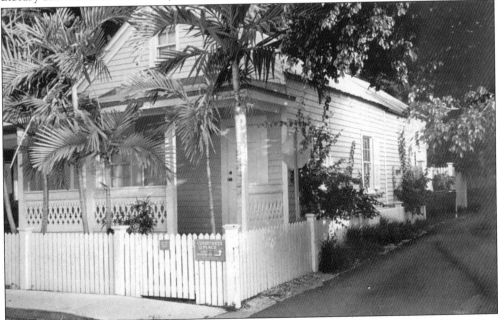

In recent years, historic inns both large and small have become part of the answer to the question of where to stay in Key West. Located on Whitmarsh Lane in the Old Town district, Courtney's Place features guest cottages, efficiencies, and private rooms carved from old Conch cottages. With its mix of laid-back atmosphere and friendly charm nestled in a historic setting, Courtney's Place personifies that special ambiance of Key West. (Authors' collection.)

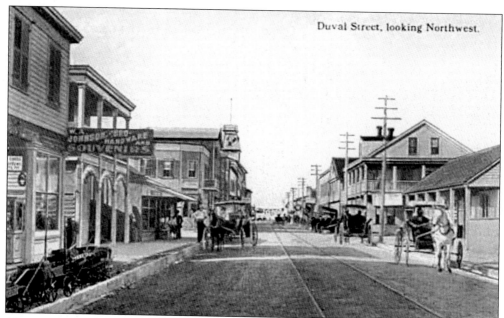

Duval Street, looking Northwest.

Almost every street in Key West has something to interest visitors. Contained in a souvenir book of 22 images, this postcard offered an early look at Duval Street, the city's best-known thoroughfare. Note that even back then, one of the stores offered not just hardware but also souvenirs. Lined with guest accommodations, restaurants, bars, art galleries, and gift shops, Duval Street currently bustles with tourist activity around the clock. (State Library and Archives of Florida.)

No longer as quiet as this postcard would indicate, Whitehead Street begins at the Key West Aquarium just off of Mallory Square and ends at the southernmost point in the continental United States. Named for John Whitehead, one of Key West's founders, Whitehead Street is also the location of the Presidential Gates for the now deactivated portion of the naval station, the Key West Lighthouse, and the End of the Rainbow sign. (State Library and Archives of Florida.)

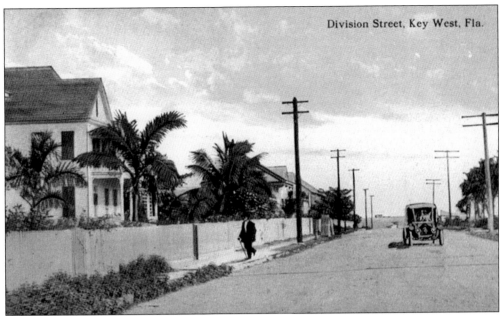

Division Street, Key West, Fla.

Streets in Key West come in all shapes and sizes—narrow tree-lined residential lanes, broader business thoroughfares, and modern highways. A visitor to Key West many years ago would have traveled down Rocky Road. By the time the upper postcard was published, Rocky Road had been renamed Division Street and was home to many of Key West's wealthier residents. Today the same street is Truman Avenue, named in honor of Pres. Harry Truman, a frequent visitor to the island. A "Natural Color Post Card Made in U.S.A. by E. C. Kropp Co." offered a view of one of the city's more modern highways—Roosevelt Boulevard. It of course was named for Pres. Franklin D. Roosevelt, who visited Key West in 1939. (State Library and Archives of Florida and Authors' collection.)

ROOSEVELT BOULEVARD, KEY WEST, FLA.—K20

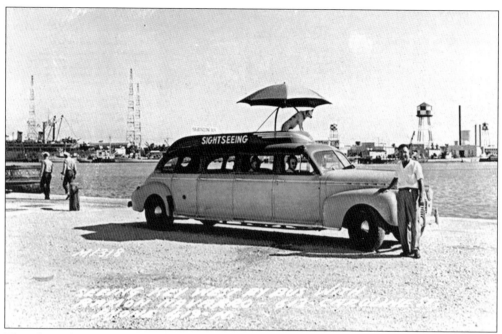

There have always been many ways to see Key West. One of the most original had to be a guided tour on Ramon Navarro's sightseeing bus. Imagine trying to describe this early version of a stretch limo, complete with a dog and umbrella on top. Better to send this advertising postcard to friends back home and let them see for themselves. (State Library and Archives of Florida.)

Less exotic but perhaps equally fun and still available today are trips aboard the Old Town Trolley. Departing from Mallory Square, the trolley makes 10 stops during its 1.5-hour guided tour. This postcard published by Keys Color Graphics pictured the Old Town Trolley as it passed the Audubon House. (State Library and Archives of Florida.)

Another way to see the Southernmost City is the Conch Tour Train, the closest approximation of a railroad in Key West today. Departing from Mallory Square every half hour every day of the week, the propane-fueled motorized tram has carried more than 10 million visitors on sightseeing tours of the island. (Authors' collection.)

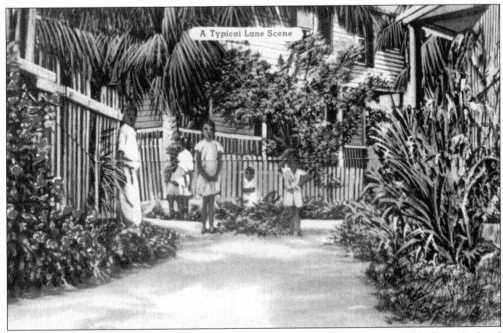

For the more athletic visitor, there are self-guided walking tour brochures available from the local chamber of commerce. From the narrow little lanes that wind through the older neighborhoods of the island, visitors can enjoy the non-commercialized side of Key West, complete with up-close views of historic properties and tropical vegetation. (Authors' collection.)

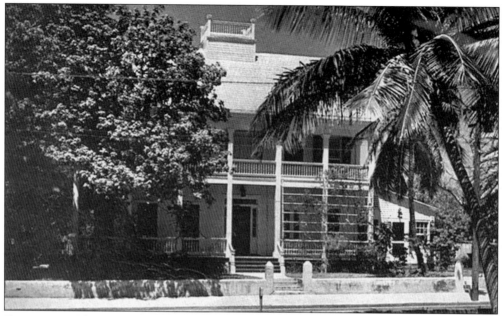

For anyone with a passion for interesting residential architecture, Key West is truly a paradise. Saunders Wholesale distributed this postcard of the Caroline Lowe House at 620 Southard Street. Built of pine and Honduran mahogany in the 1850s, the dwelling was one of the finest examples of Bahamian architecture in Key West. During World War II, the house served as a canteen for the USO and later as a hospital. (State Library and Archives of Florida.)

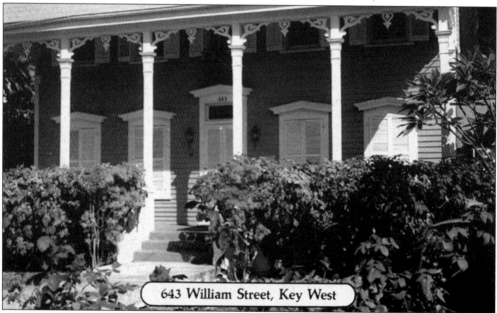

643 William Street, Key West

Equally interesting was the "eyebrow" house at 643 William Street. Edward Roberts, a ship's carpenter from Ireland, designed and built the two-story dwelling in a style unique to Key West. Although the overhanging roof obscured some of the view from the upper floor, it provided essential shade to cool indoor temperatures in the tropical climate of Key West. (State Library and Archives of Florida.)

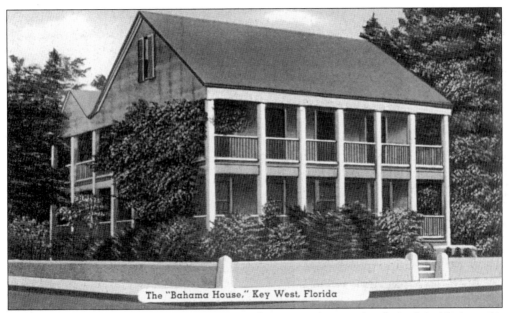

The "Bahama House," Key West, Florida

When some of Key West's early residents came from the Bahamas, they brought with them the architectural styles of home. One of 20 images in a souvenir postcard folio, this view of the Bahama House displayed the classic Bahamian-style trademarks of a wraparound porch and wood-shuttered windows. Built of New England white pine, the residence was constructed in Green Turtle Bay in the Bahamas and later dismantled, shipped to Key West, and reassembled. (Authors' collection.)

This postcard depicted not a building, but rather a painting of a building. Richard Sargent painted this view of what for many years was famous as the southernmost house in the United States. An artist for the federal Relief Art Project during the 1930s, Sargent painted several works that remain in the Key West Administration collection. Located at 1400 Duval Street, the dwelling was built in 1900 for Judge Jeptha Vining Harris. (State Library and Archives of Florida.)

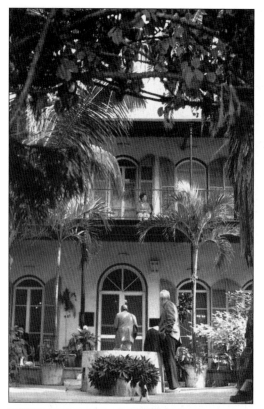

Located at 907 Whitehead Street, the Ernest Hemingway Home and Museum remains a popular stop on any visitor's tour of Key West. Florida Keys Wholesalers published the top postcard depicting the front patio, while the bottom view of the exterior was included in a 20-card souvenir folio. Well-known designer William Kerr is believed to have built the home for Asa F. Tift, an early Key West wrecker and wealthy entrepreneur. After Hemingway purchased the residence in 1931, it underwent extensive remodeling. Among its unique elements were a basement and the island's first swimming pool. In his writing studio on the second floor of the carriage house in the backyard, Hemingway wrote some of his best literary works, including *A Farewell to Arms*, *Death in the Afternoon*, and *To Have and Have Not*. (State Library and Archives of Florida and Authors' collection.)

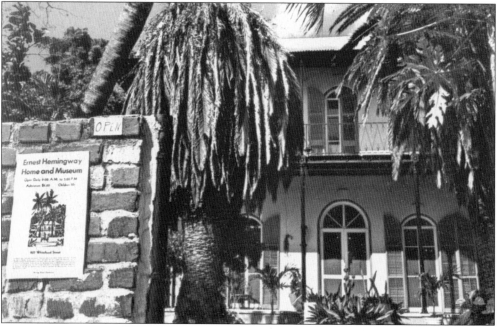

Almost as famous as the dwelling or the literary genius that inhabited it are the dozens of cats who live at the Ernest Hemingway Home and Museum. According to the description on this Plastichrome postcard of the patio, "1931–1961. There is an average of 40 cats on the grounds of the Hemingway estate. These are descendants of Hemingway's 50 cats. The cat fountain in the background is made from a Spanish olive jar and the plumbing fixture is from Sloppy Joe's bar." As an additional point of interest, visitors may notice that many of the cats are polydactyl. This means that the cats possess a genetic trait that causes them to have extra toes on their feet. (Authors' collection.)

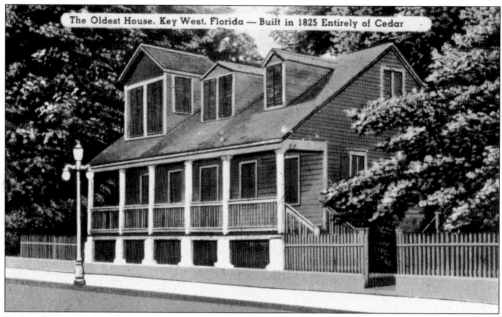

The Oldest House, Key West, Florida — Built in 1825 Entirely of Cedar

Built of cedar in the 1820s by a ship's carpenter, the Wreckers' Museum/Oldest House is another popular tour stop in Key West. The 1.5-story house was located on the corner of Caroline and Whitehead Streets until mule teams and lots of muscle moved it to its present location at 322 Duval Street. Donated to the State of Florida in 1974, the museum serves as a reminder of the wrecking industry's importance to local history. (Authors' collection.)

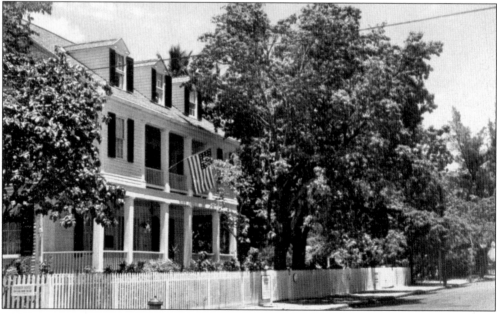

Although this postcard from a souvenir folio showed the building known as Audubon House, the structure was actually built as the home of Capt. John Geiger, a Key West harbor pilot and wrecker. While the gardens showcase a variety of native plants, the museum contains a number of engravings that naturalist John James Audubon completed for his book *The Birds of America* during his visit in 1832. (Authors' collection.)

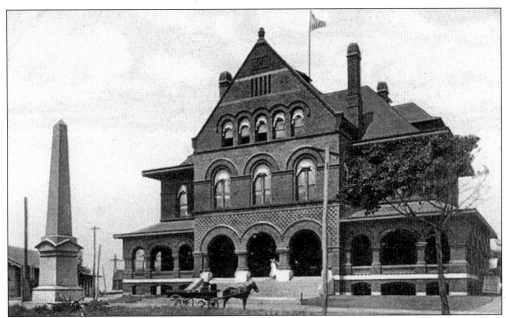

Housing the federal offices of the courts, customs, postal, and lighthouse services, the U.S. Custom House opened in 1891 after construction that required nearly three years and $108,000. Subsequent use as the Naval Administration Building buried details of the structure's late-19th-century eclectic architecture, with its Queen Anne and Richardsonian Romanesque features. In 1999, after a $9-million, 10-year restoration effort returned the structure to its former elegance, the building reopened as the Key West Art and History Museum at the Custom House. Located at 3501 South Roosevelt Boulevard, the East Martello tower, a Civil War military fortification, has also received a new lease on life. Under the auspices of the Key West Art and Historical Society, exhibits pertaining to the Florida Keys and works of art by local artists fill the East Martello Museum and Gallery. (Key West Art and Historical Society and State Library and Archives of Florida.)

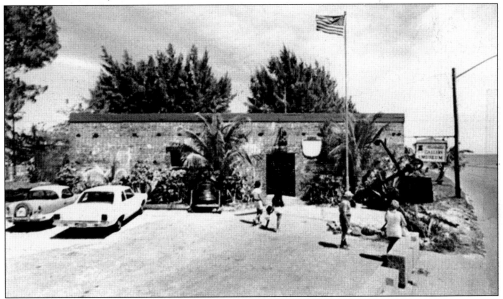

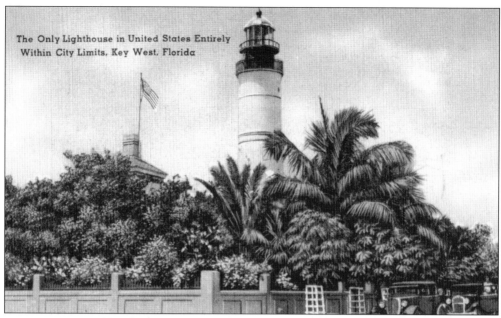

The Only Lighthouse in United States Entirely Within City Limits, Key West, Florida

For many years, postcards have touted the Key West Lighthouse's claim to fame as the only lighthouse in America to be located entirely within the city limits. After the hurricane of 1846, the lighthouse was rebuilt further inland at 938 Whitehead Street on a site an additional 14 feet above sea level. As the city grew and tall buildings obscured the lighthouse's beacon, 20 feet were added to the structure in the 1890s. (Key West Art and Historical Society.)

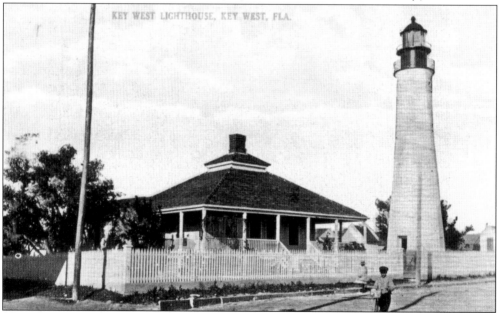

KEY WEST LIGHTHOUSE, KEY WEST, FLA.

The lighthouse and its adjacent lighthouse keeper's quarters were decommissioned in 1969. Three years later, the Key West Art and Historical Society reopened the site as the Key West Lighthouse Museum. Even while the lighthouse was in active operation, however, it was still popular with visitors, as evidenced by its listing in an 1882 edition of *Florida for Tourists, Invalids, and Settlers*. (Authors' collection.)

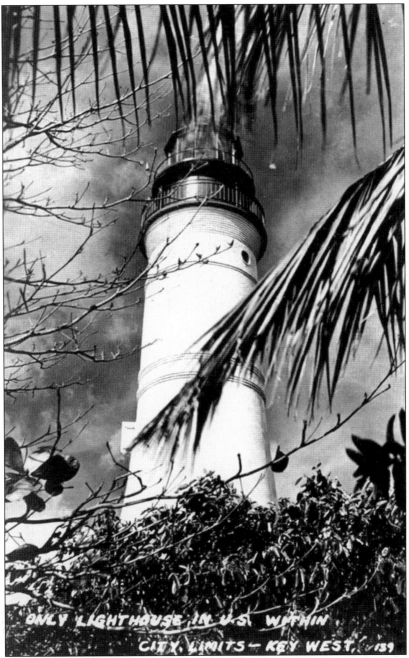

ONLY LIGHTHOUSE IN U.S. WITHIN CITY LIMITS — KEY WEST, 139

No trip to the Southernmost City would be complete without a visit to the Key West Lighthouse. While a tour of the restored keeper's quarters evokes images of the lighthouse keeper's daily life, more athletic visitors can climb the 88 steps of the winding spiral staircase to the top of the lighthouse and treat themselves to a breathtaking panoramic view of the city. With just a little imagination, they can envision what it would have been like to make that trip every single day, especially while carrying with them enough fuel to keep the lamp burning throughout the night. Those same visitors can also imagine how glad they would have been when the light was electrified in 1917, eliminating that onerous duty. (State Library and Archives of Florida.)

Key West's original tourist attraction was its aquarium, built by Depression-era workers from the Federal Emergency Relief Administration. Billed on the top postcard as the "only tropical open-air aquarium in the country," the idea was originally suggested by the director of Philadelphia's Fairmount Park Aquarium. Renovations in the 1980s enclosed the building and many of its exhibits, making it possible for tourists such as those pictured in the bottom postcard to enjoy up-close encounters with marine life regardless of the weather. (Authors' collection.)

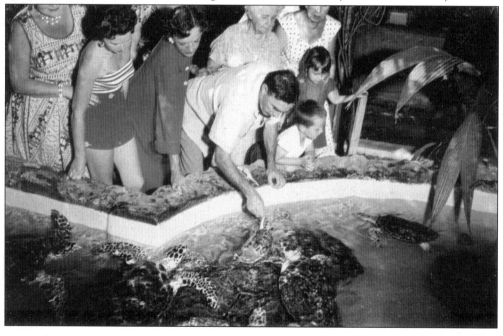

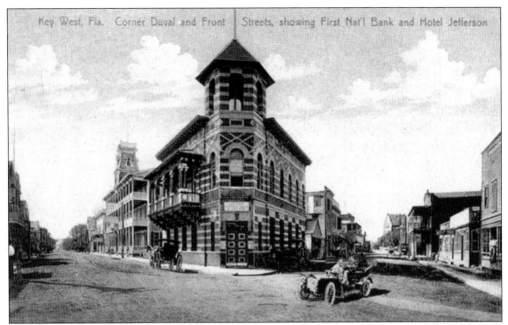

Architecture buffs aren't limited to surveying Key West's residences. They can also enjoy the interesting designs of a number of commercial properties. This postcard of the wedge-shaped First National Bank on the corner of Duval and Front Streets bears a 1911 postmark. In a tribute to a strong preservation movement, nearly a century later, the impressive building looks much the same. (State Library and Archives of Florida.)

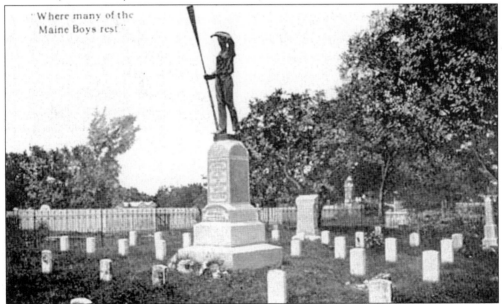

Captioned "Where many of the *Maine* Boys rest," this postcard commemorated the deaths of 266 American sailors in the explosion of the USS *Maine* in Havana Harbor, an event that triggered the Spanish-American War in 1898. Surrounded by a cast-iron fence near the Margaret Street entrance to Key West Cemetery, the *Maine* monument is a full-sized sculpture of a sailor standing atop a granite pedestal. (State Library and Archives of Florida.)

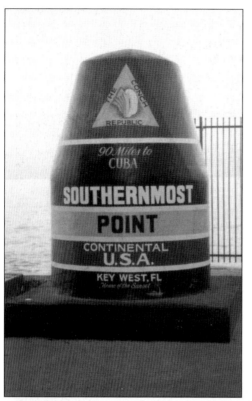

Some visitors have their pictures taken next to this colorful buoy; others are content to send home a postcard view of it. In 1983, the City of Key West installed the mammoth, nearly nine-ton marker to designate the spot that is the southernmost point in the continental United States. Located just 90 miles from Cuba, the monument has been a local landmark ever since. (Authors' collection.)

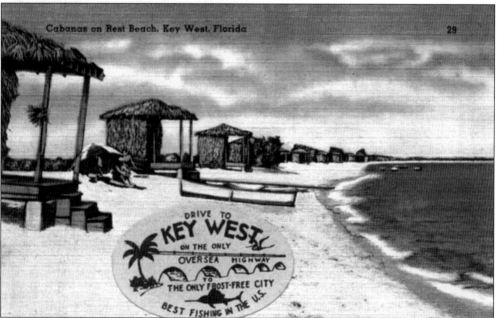

To turn it into an advertising tool, an enterprising promoter added an oval sticker to this linen-finish, Tichnor Brothers postcard of the cabanas on Key West's Rest Beach. Urging visitors to "Drive to Key West on the only Oversea Highway to the only frost-free city," the addition modestly promised the "best fishing in the U.S." (State Library and Archives of Florida.)

This postcard of "The beautiful schooner *Appledore* under sail in Key West, Florida, the southernmost point of the United States" offered an ideal way to inspire envy in friends and relatives back home, especially in the midst of a nasty cold winter. Other opportunities for nautical adventures on the waters around Key West also exist. Visitors can choose a high-speed trip to the Dry Tortugas or a more leisurely sailing, snorkeling, and beach-combing catamaran excursion. Enjoy a trip to nearby coral reefs on a glass-bottomed boat. Rent a Waverunner or try a kayaking tour. Take the wheel of a tall ship or kick back and relax during a dinner or sunset cruise. (Authors' collection.)

Published by Keys Color Graphics, this postcard proved the old adage that a picture is worth 1,000 words. What could better typify the perfect ending to a perfect day than this image of the three-masted, 86-foot windjammer *Appledore* silhouetted against that famous Key West sunset? And what could better summarize a visit to the Florida Keys than this postcard published by Florida Keys Wholesalers? Its caption reads: "This beautiful painting by Jeanne Faught shows the Florida Keys islands going southwest out to sea from the Florida mainland. The beautiful flowers, birds, shells, and colorful fish are grouped around the painting." Truly the Florida Keys possess all of those things and more, but don't just take our word for it. Everyone should experience Key West and the Florida Keys firsthand. (Authors' collection.)

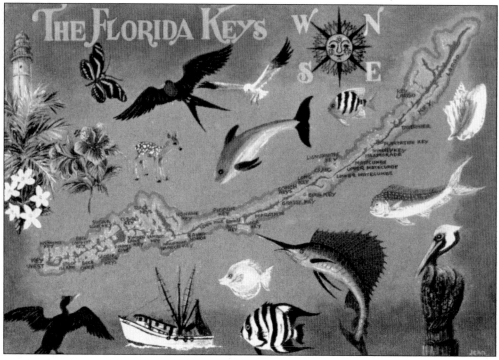